PAINTING
WATERCOLOURS
ON CANVAS

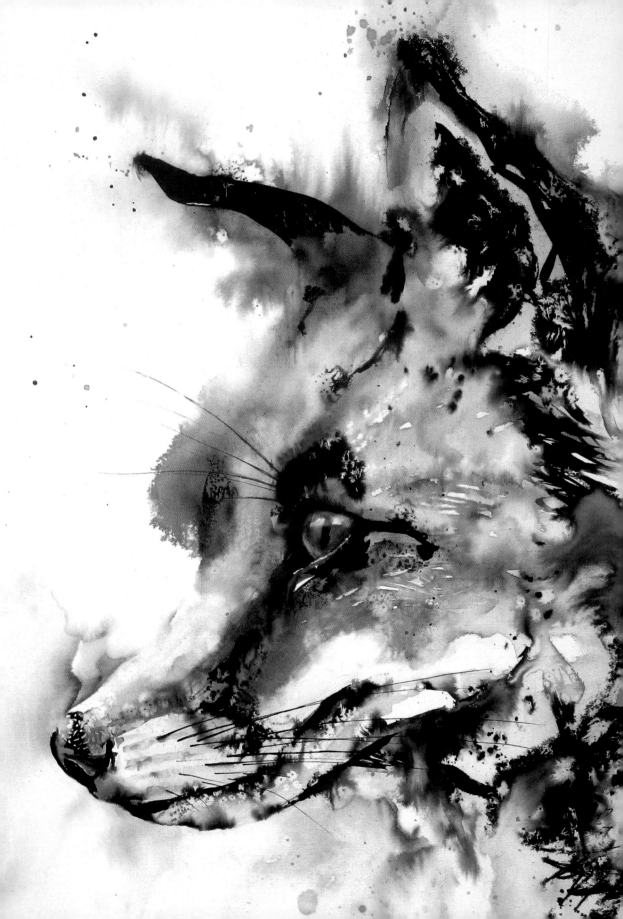

PAINTING WATERCOLOURS ON CANVAS

Liz Chaderton

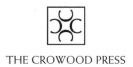

THE CROWOOD PRESS

First published in 2019 by
The Crowood Press Ltd
Ramsbury, Marlborough
Wiltshire SN8 2HR
enquiries@crowood.com
www.crowood.com

This impression 2022

British Library Cataloguing-in-Publication Data
A catalogue record for this book is available from the British Library.

ISBN 978 1 78500 589 3

Acknowledgements
Thank you to all the artists named in the text for letting me reproduce their beautiful work.
I hope they inspire you to try new subjects and styles. Grateful thanks also to fellow artist
Liz Baldin for all her encouragement and feedback as I put together the initial proposal for
this book. I also appreciate the help and advice from The Crowood Press in making this book
a reality. Finally, thank you to my husband Ian for his support, and to my sons Adam and
Alex for letting me commandeer their table tennis table, which is perfect for painting large
canvases upon.

Frontispiece: *Mr Fox*, cropped, originally 70 x 70cm, ink and watercolour on canvas.

Typeset by Jean Cussons Typesetting, Diss, Norfolk
Printed and bound in India by Parksons Graphics

CONTENTS

INTRODUCTION

Let me say this straight away – I am passionate about watercolour. It is a medium of highs and lows; unpredictable, immediate, vibrant and responsive. But it can be frustrating. The inability to correct mistakes, the tendency to overwork the surface, the need to hide your lovely painting behind glass, the cost and hassle of framing, not to mention the dismissive attitude of some people towards work on paper.

So when I first came across the notion of painting on canvas, I was intrigued. I was already aware of the central role that the surface plays in a painting. The transparency of the medium means the paper surface becomes an integral part of the finished image. I had tried all sorts of papers from the ultra-smooth Yupo to rough blotting-type handmade papers made in the Himalayas. But canvas?

My previous plays on ordinary canvas had ended up as a frustrating mess. Here was an opportunity to try something completely new.

This book challenges the notion that watercolours must be painted on paper. It invites the artist to free their paintings from the constraints of glass and mount. We can move from the set sizes of watercolour sheets and step into the limelight of scale, should we so desire.

Blue Flamingos, 80 x 60cm, from the collection of Jane and Bernie Chambers. Watercolour on canvas is not restricted by size or the weight of framing and there is nothing to come between the viewer and the image.

LEFT: *Blue Flamingos*, cropped, 80 x 60cm originally, watercolour on canvas.

'What happens if?' is one of the most important questions you can ask yourself. You will be rewarded with happy accidents; here, dropping water into a drying wash.

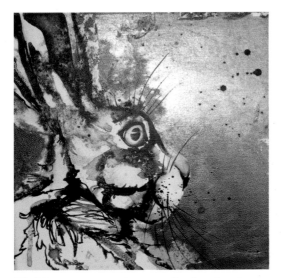

Working on canvas gives you the freedom to start exploring mixed media. *The Stare* – ink, watercolour and imitation gold leaf on a 25 x 25cm deep edge canvas.

You know that watercolour is a tough medium to master. Its key characteristic of transparency makes it so. In fact, I am not sure the artist ever masters watercolour. Just when you think you are in control, it will poke you and show you who is boss. Equally just when you are feeling low and ready to give up, it will make you a little present of a 'happy accident' which will motivate you to continue your journey.

If you are concerned about the longevity of watercolour on canvas, let me put your mind at rest. Canvas, being made of cotton or linen and wood, is a natural product and will respond to the environment, especially humidity and fluctuations in temperature. However, this is true regardless of which medium you are using. The grounds and preparations for watercolour are designed to be archival, for instance, they will not yellow or degrade over time. The pigments you use will be as fugitive or permanent as when they are used on paper; the use on canvas has no impact upon their permanence. By using artist quality pigments with the highest possible lightfastness ratings, you will assure the life of your work. By sealing and protecting the finished piece with a UV resistant archival varnish, the painting will be more protected from the ageing effects of UV light, than under ordinary picture glass. I believe the artist can paint with confidence and the collector can buy with confidence, knowing that the canvas will continue to retain its vibrancy over the years.

This book shares my learning about using our unpredictable friend on a new surface. I want this to be a very practical book, so I will get down to the nitty gritty of what to do. But it comes from my experience of what works for me. There is no right or wrong in painting, just what helps you communicate through your art. So use it as a starting point to avoid the obvious pitfalls and then build on it to move forward.

I do not intend this as an introduction to watercolour painting, there are some excellent and thorough books already available that do that job. Neither is it a guide to painting in a loose and impressionistic style, though that is my natural tendency. My passion is painting

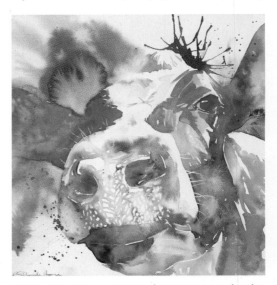

Flicker, 30 x 30cm, watercolour on canvas by the author. Colours stay vibrant and spontaneous on the prepared canvas surface.

animals and subjects from nature. However, I do not propose this as a book about those subjects, though of course, they are the examples I choose to illustrate techniques. This book is firmly about painting on a new substrate and how to get the most out of it. The preparation, method or working process will be in common, whichever subject you choose or whatever your preferred style.

If you are starting out you may not have the preconceptions more experienced painters have, so canvas might be a fabulous substrate for you. If you are experienced you may wish to break out of the confines (size, presentation, mindset) of paper-based painting; if less experienced you may want to explore new surfaces or just prefer the contemporary look of canvas.

I think the most important question to ask is 'What happens if…?'. Artists are always looking for new ways to express ideas, so read this book with a spirit of adventure and have a go. If the first experiment doesn't work, what's the worst that can happen? Just wash the paint off and start again.

This book aims to short circuit some of the learning for you and will guide you towards the materials I find work well and introduce you to some of the technicalities of canvas, which acrylic or oil painters take for granted. I hope it will also inspire and introduce you to the possibilities. The step-by-step demonstrations are aimed at introducing different techniques. You can either follow them in detail or apply them to a subject of your own choosing and integrate the parts you like into your practice, while rejecting the techniques that don't work for you.

But before we dive into those practicalities I want to reiterate the case for canvas.

I hope that by the end of this book, you will be as excited as I am about the new possibilities working on canvas offers and will be eager to experiment and push your art to the next level.

THE CASE FOR CANVAS

- Watercolour on canvas retains its beautiful transparency and apparent fragility, and yet it can be displayed without glass and a mount.
- The distraction of glare from the glass or an ill-chosen frame no longer gets between the viewer and the image.
- Unframed canvases have a more contemporary feel than formally framed work.
- The cost of framing no longer has to restrict your output or the size to which you work. Indeed, using a deep edge canvas, no framing is required at all.
- Handling and storing paintings is easier. Not only is the weight of the glass removed, so is the potential to chip frame corners, or crack sheets of glass.
- There is no restriction on size – well, the only restriction is the length of your arms. Now, should you wish, you can pick out a metre canvas and know that you can really make a statement. However, if working on a smaller scale is your preference, it is still open to you.
- Annoyingly, works on canvas are considered more valuable than those on paper. And some collectors worry about the durability of paper. By working on canvas you can overcome both misconceptions.
- The finish you give to your work can combine the brushwork of oil with the transparency of watercolour.
- And if the worst comes to the worst, you can scrub the canvas under the tap and start again.

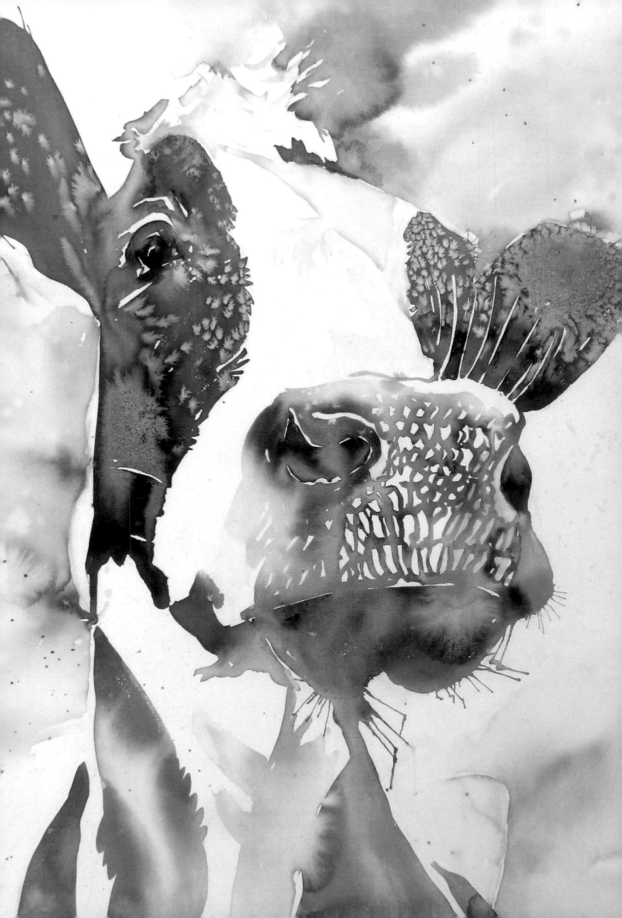

SUPPLIES, MATERIALS AND EQUIPMENT

Paints, brushes and other supplies

While this book is not intended as an introduction to the joys of painting in watercolour, it is worth briefly revisiting the basics.

Even if you are an experienced painter, the demands of the canvas surface mean you will need to look again at some of your materials; canvas is tough on soft brushes, pigments need to be chosen for maximum lightfastness, quantities alter as you change the scale of your work, even your eraser may need to be adjusted.

Get your supplies ready and laid out conveniently before you start. If you are right-handed it is best to have them to the right of the canvas, with reference materials to the left.

LEFT: *La Vache*, 50 x 50cm, watercolour on canvas.

Good quality materials, suited for the effect you are after, will make your painting time more pleasurable and ensure that you get as close as possible to achieving your vision.

If you are starting out, it is worth considering the materials you wish to invest in, making sure that they will work with you rather than hinder your progress. Every artist has a cupboard of supplies, bought on impulse but rarely used. Let us not add to this stock pile, but make each part of your painting kit a valued contributor.

Paint

All paints are made of pigment plus a binder. While oil paints are bound with linseed oil,

Colour is a joy in watercolour, but you don't need a huge range to get started though you will, no doubt, accumulate a wonderful variety over time.

acrylics with an acrylic polymer, tempera with egg yolk, watercolour paint is pigment plus a binder of gum Arabic. The same pigments are generally used throughout – only the binder and additives differ.

Watercolour paint is available in two different physical forms – tubes or pans (sometimes called cakes), and is available in two different qualities – student or artist.

Given that one of the prime motivations of painting on canvas is the richness of the colour that can be achieved and the lack of restriction in size, it makes sense to opt for tube colours – it is far easier to be generous and to mix up rich creamy washes. The colours are less likely to be contaminated, as they are kept in sealed tubes.

On the other hand, pans are certainly convenient and portable. They tend to be more

The Hare Who Ate Too Many Cornflowers, 90 x 90cm, ink and watercolour on canvas. Artist quality pigments move and flow with a life of their own on the canvas. They have a special vibrancy, so it pays to use the best you can afford.

compact, if storage is an issue. Should you opt to use pans, then spraying with clean water as you are preparing to paint will pre-moisten the cakes, letting them release their colour more readily. It will help you avoid having to scrub the pan endlessly to mix up a creamy wash. If you are painting outside, or sketching, pans are easy to maintain and use. One drawback is that colours can become contaminated rather easily when going from pan to pan without washing your brush.

Artist quality paints rather than student quality will reward you in the long run. Student quality are less expensive because some of the good stuff has been left out and cheaper filling elements have been used in their place.

Artist quality paints use the best quality and the most finely ground pigments. These are likely to have better lightfastness properties, as well as vibrancy. You will notice that artist pigments have more life and respond as they move around the surface through the water. In general, use the best quality paints you can afford. The own-brand artist quality paints from the big retailers are often of very good quality and considerably cheaper than the branded tubes. If you are on a more restricted budget you will find that the student range from well-known manufacturers such as Winsor and Newton or Daler-Rowney offer a consistent and affordable choice. But be warned, once you start trying artist quality pigments you will find it hard to go back. Art suppliers have regular sales, so you should be able to find good quality supplies at an affordable price without having to compromise.

Each of the major global brands offer a stunning array of colour choice – perhaps with up to 250 colours. Patently you cannot afford and certainly do not need this many. You may find you prefer one brand over another, but more likely, you will end up having a favourite colour within individual ranges. Some of the more standard colours will be indistinguishable, but often paint with the same name will differ entirely. You will need to check the pigment reference to be sure of what you are buying (*see* box). Do consider the size of tube you buy. It is hard to be generous with a colour if you only have a tiny 5ml tube.

Many people consider gouache to be its own form of paint, but it is really an opaque form of watercolour. Most artists choose to create paintings exclusively with gouache, but it can also be used in conjunction with watercolour to strengthen highlights or intensify colours. A tube of white gouache is certainly a useful addition to your paint box and can be used to add a few finishing details.

Looking after your paints

Even if working on a larger scale, you do not get through a large quantity of watercolour paint. If you look after your paints they will last years.

Assuming you have chosen tube colour, start by squeezing the tube from the bottom. Make sure you put the lid back on tightly. If a tube becomes hard over time, don't throw it away. Slice it open with a sharp knife and peel back the tube. Use it like pan colour. If you get a puddle of clear liquid when you squeeze colour out, the gum Arabic has separated. Put the lid on and massage the tube to mix the paint. Some colours are prone to this separation. Store the tube on its lid and the liquid will rise to the top (in effect the end of the tube), allowing you to squeeze colour out. If you have paint in your palette you can simply let it dry and add water to reactivate it upon resuming your painting. It is possible, though rare, for tube colour to go 'off'. The smell is unmistakeable; just throw it out.

If you are using pan colours, ensure the box is fully dry before closing and storing it. In hot, humid areas you can find mould will take

hold. In such a case, spray with dilute surgical spirit/rubbing alcohol or even vodka to kill the spores. A gentle wipe with antiseptic should also work. Exposure to strong sunlight will have a similar effect. If you are struggling to keep the fungus at bay, then a cotton ball soaked in alcohol left in the box should prevent growth, or the small sachets of silica found in shoeboxes, could be kept in your paint box to absorb moisture. You may find it is your water source which is causing the contamination. Consider using distilled or

GUIDE TO USEFUL INFORMATION ON A TUBE

Have you ever considered the information on the side of your paint tube? It can be incredibly useful.

Colour name
This is the name of the colour which is not necessarily unique to a range or manufacturer. Just because it is called the same name, does not mean it is the same colour.

Series number
An indication of the relative price of the colour. Usually series 1 is the least expensive. Price usually reflects the expense of the pigment.

Permanence rating
Measures lightfastness and depending on the manufacturer, may also take into account the stability of the paint. Look for paints with the highest rating.

Lightfastness may be shown with an ASTM rating for the pigment. The ASTM abbreviation stands for the American Society for Testing and Materials. I and II are considered permanent for artists' use. If you are not displaying work, lightfastness will potentially be of lesser concern.

Pigment code
Every pigment is identified by its Colour Index Generic Name. This allows you to compare different manufacturers' formulations and accounts for why they are not always visually the same colour. More than one pigment abbreviation indicates multiple pigments, which is worth knowing to avoid mixing muddy colours.

It is worth becoming familiar with your pigments. Somewhere on the tube there will be useful information which should indicate the pigment number, the transparency, permanence and staining characteristics. However, information varies from maker to maker and will become obscured as you use the tube.

Opacity
Symbols are used to represent the transparency/opacity of a colour. Transparent colours are marked with a clear circle or square, semi-transparent colours are marked with a diagonal line and opaque colours are marked with a filled-in symbol.

Granulating/staining
Not all manufacturers show this but if marked as G, the pigment granulates. Staining colours are those that cannot be lifted with a damp sponge and are marked as St.

bottled water. Some manufacturers add a fungicide, some say that the honey added to their formulation is naturally anti-fungal. It should not be a problem if you care for your paint box.

A basic palette

A great starter palette consists of a warm and a cool primary, a couple of earth colours and perhaps a 'treat' colour. This should see you through just about any subject. So select one from each of the first six and then any of the remaining you fancy.

- Cadmium yellow/gamboge/quinacridone gold/Indian yellow
- Lemon yellow
- Cadmium red
- Alizarin/quinacridone rose/carmine
- French ultramarine/indanthrone blue
- Cerulean/Prussian blue/phthalo blue

- Burnt Sienna or burnt Umber
- Raw Sienna
- Raw Umber
- Dioxazine purple/manganese violet
- Viridian/pthalo green
- Sap green

A small tube of white gouache (opaque water-colour) is useful for missing highlights.

Colour is a joy, but don't try to use too many colours in one painting. A limited palette will be more harmonious. As you gain experience really get to know your pigments – are they transparent? Do they stain? Are they a single pigment or a mix? Such knowledge will make you a better painter.

Water

Water is your friend and brings the pigment to life. One of the eureka moments of most watercolourists is when they realize that if you

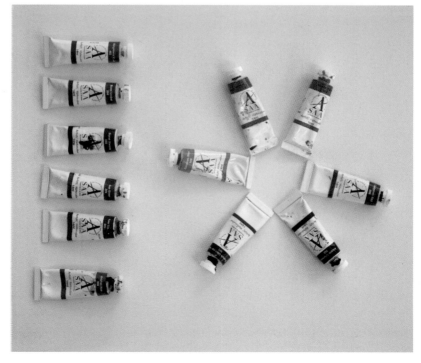

A warm and a cool primary is vital (in a circle on the right) and a few earth colours, plus a ready mixed green and purple make up a good starting palette. Do mix and match your brands, but try to use artist grade paints whenever possible.

DON'T FORGET

Watercolour is transparent – sounds obvious, but you can paint dark colours over light and they may optically mix on the surface but essentially cover, you can't do it the other way. Water brings the paint to life. If you put on too much pigment and too little water, your painting will be flat and lifeless. Watercolour dries lighter than wet. So paint darker than you intend if you don't want the end image to be watery. This is not as marked on canvas as paper. You will find that colours are more intense on the canvas substrate, so to avoid being garish adjust your paint/water mix.

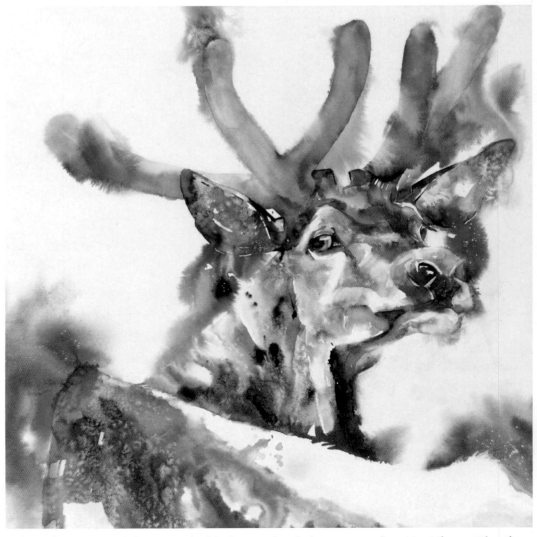

Making the water work for you and achieving tonal variation are more important than getting the exact colour match. This stag uses soft edges and wet in wet extensively.

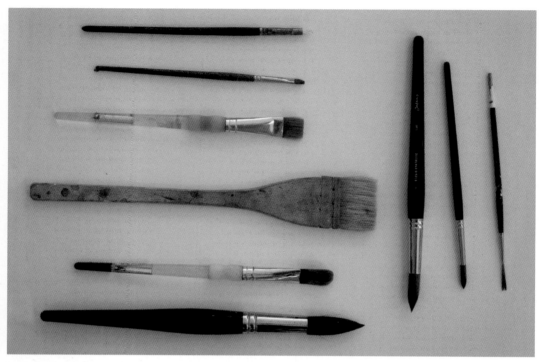

You don't need many brushes – a large round, small round and small rigger will be more than sufficient (on the right). However, always choose an appropriately sized brush for the size of work you are doing.

control the water on your brush and therefore the water on your surface, you are halfway to taming this unpredictable medium. Colour will follow the path of the water. Worrying less about the colour and more about the water will make for better paintings and a happier artist.

Two large pots of water are essential – one to wash your brush and one to mix up clean colours. Change them often and be disciplined about it. Muddy water will contaminate everything. As paint can dry very quickly in a warm or dry atmosphere, mixing colours with water in your palette ahead of starting to paint will ensure you do not have to stop and risk hard edges in the middle of a passage.

A small fine spritzer is very useful to soften edges, pre-wet the surface, or move paint around on the canvas. Avoid large 'window-cleaning' spray bottles as they will wash away the frag-

ile colour. You can also fill spritzers with diluted paint to glaze an area if you are concerned about disturbing the underlying washes.

Brushes

Canvas is a far tougher surface to work on than a traditional paper. While you will still need good watercolour brushes, you may wish to consider hard-wearing synthetics, over the softer natural fibres such as sable. A Kolinsky sable brush is expected to last a lifetime if cared for and used on paper, however, you will find the more wearing canvas surface will shorten its span considerably.

Good watercolour brushes can be expensive, so what do you really need? Three or four basic brushes should see you through most subjects;

a large round size 16, a small round (size 8) and a rigger (size 2). A flat brush is a good add-on and you may find you want to work with one all the time as you develop a personal style.

These recommendations will depend on the size of painting you intend to pursue. As a general rule one should start with the largest brush and then move to small brushes as detail is added. If you aspire to paint loosely, a brush that feels slightly large for the space you are painting is probably about the right size. We all tend to take comfort from being in control and using a small brush gives us that illusion. In fact, an overly small brush automatically tightens the painting style and will often stop us achieving the impact we are searching for.

A round brush should have a good fluid carrying capacity in its belly, should be soft to work with but still have enough spring to respond to your touch and have a decent point.

If you have invested in quality brushes, you will need to look after them. Despite the wear from a hard canvas they should last for years. When in use, don't leave them standing in your water pot as one might with acrylics – it is the quickest way of ruining the point.

When pigment particles build up at the base of the brush, it pushes hairs apart and stops the point from forming. To avoid this, clean your brush thoroughly in water after use. You can use mild soap and cool water to rub the hairs in the palm of your hand before rinsing. Repeat if required, then dry, reshaping the point. Strong soap may damage the hairs by removing natural oils. Hot water may cause any remaining paint in the brush to clot. If you notice a stain in your bristles, this should not be a concern as it will have no effect on the performance or life of the brush. This cleaning process is particularly important if you have been using ink with your brushes (*see* Chapter 5).

If possible, store tip down hanging from a rack, as this will allow moisture to drain from under the ferrule. Realistically this may not be practical, so store when dry in a brush roll or in a jar with the hairs pointing up. Do not store standing on the tip.

Add-ons

Palettes may be plastic, metal or ceramic. Given that you may wish to mix large amounts of paint into washes, one with deep wells is good. A daisywheel ceramic palette is a practical option as it forces you to choose and limit your colour palette ahead of painting and the end image is often better for the use of a limited range. The danger of using a box with twenty-four pans, is that you don't think about and plan your colours. The mixing area may be limited in a daisy wheel, so you can either use a second one, or a simple white plate. Plastic palettes can stain over time, making an accurate assessment of your colour harder. On the plus side, they don't break when you drop them!

You will probably want to sketch your composition onto the canvas to give you a guideline. Some artists do not like these pencil marks to show in the final piece, others say they are honest and part of their process. Even if using an H or HB pencil, you will find it hard to erase lines from the canvas. Magic Eraser is a high friction melamine foam. Its microstructure is hard which allows it to work like a super fine sandpaper. With the addition of water, it is an excellent way of removing unwanted graphite or pigment. It is available from art suppliers or because of household cleaning applications, you are likely to find it far cheaper in a hardware shop or the cleaning aisle.

Paint will dry slowly on the canvas due to lack of absorption, so a hairdryer will help. Being in control of the water is key, so paper towels to blot your brush or lift pigment are very handy.

Other items such as masking fluid, texturing materials and fixative will help, but these are covered in later chapters.

Semi-absorbent ground

Semi-absorbent ground is the thrilling ingredient that makes this new way of working possible. If you paint watercolour onto a standard canvas, you will find that the paint just sits on the surface. It pools up and has trouble adhering. To enable canvas to accept the paint, we need to make it more absorbent.

New products are coming onto the market constantly as the manufacturers come up with innovations. Therefore this information is correct at the time of writing, but do keep your eyes peeled.

Each of the grounds perform slightly differently. One is not better or worse than the other, and you may well develop a personal preference as you experiment. Each manufacturer gives different instructions on the number of layers in the preparation and of course price varies too.

Before we look at the grounds, we should perhaps mention the easiest option of ready-prepared watercolour canvas.

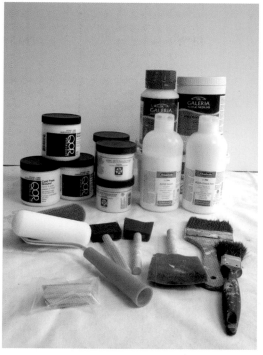

Before the canvas can accept watercolour paint it needs to be prepared with a ground. A range is available from art suppliers or you can make your own.

Ready prepared canvases

Given how easy it is to transform a shop bought stretched canvas into one suitable for watercolour, you might question why ready prepared canvases are needed. If you are short of time and just want to see if this surface suits your style, then they are the obvious answer.

These specialist canvases are available in a limited range of sizes, already prepared with a semi-absorbent ground. They tend to be made of light weight cotton duck, possibly as light as 250g/m², so are suitable for smaller works only. They are acid free, so longevity is not an issue. They do not tend to be available in a deep edge, so they will need framing in order to be displayed attractively.

Naturally convenience comes at a price and you will find they are more expensive than preparing your own. There is lack of flexibility in the surfaces available, so if you are looking for a rougher or smoother surface, you will not find it.

Look out for brands such as Frisk, Yes! and Fredrix. At the time of writing, Yes! is not available in the UK, but is said to offer superb vibrancy of colour and unique colour mixing opportunities on the surface.

You can also buy ready prepared canvas on a roll, or sheets of canvas in a book. Fredrix has a roll 147cm/58in wide, which some retailers sell by the metre.

You will need to support the sheet of canvas before painting, for example, stapling to a MDF board or even to thick foam board, otherwise it will buckle.

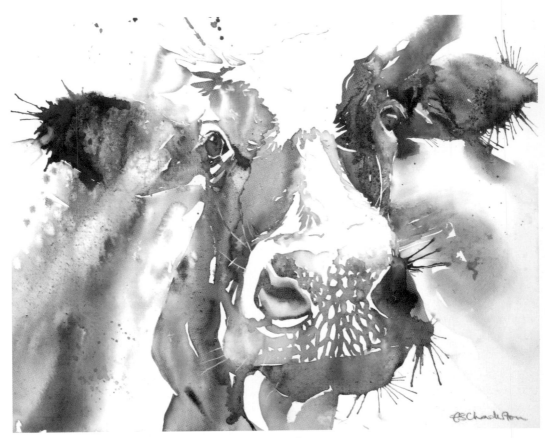

Pink Cow, 40 x 30cm, painted on a ready prepared Frisk canvas.

If you are travelling you will not be taking pre-stretched canvases in your hand luggage, but you could take sheets of pre-prepared canvas and then stretch them upon your return.

Grounds

And now to the magic ingredient. Let's explore the grounds available to you, examining the colour, finish, application and any distinguishing features. Each works well, but you will find each responds slightly differently. Just as all watercolour papers have different characteristics and you develop a preference for one brand, you will probably like one ground more than another. The choice is yours. If you feel you are getting stuck in a rut, then try a different one.

You should note that the more coats you put on, the greater the absorbency. While one manufacturer optimistically says a single coat may be sufficient, experience says that three coats is generally better. Some people use five or six thin coats, which I find excessive. To obtain a smoother finish, each coat may be gently sanded once dry. A fine, wet and dry sandpaper will avoid leaving scratches in the surface.

Each product comes in different sizes, so depending on the quantity you require you may find one better value than another. Each may be thinned with differing amounts of water to enhance the application. Check carefully as this

varies between 10 and 25 per cent. Too much water will weaken the acrylic bond and will be a false economy as it will impact the future stability of surface.

While our focus is on painting on canvas, do note that these grounds can be used as a correction fluid on ordinary watercolour paper. They can also be applied to most surfaces – absorbent or not.

Semi-absorbent gesso

As well as the grounds produced solely for use with watercolours, there are a number of gessos which might be of interest to the adventurous watercolourist. These are designed to prime canvas for use with oil, acrylic and tempera painting. They are especially formulated for glazing techniques.

It is impossible to identify every gesso in the world and rate them on an absorption scale but a few are worth particular mention. You might find them easier to source than the specialist grounds, so it could be a good idea to test any you come across. You may find a primer that really suits the way you work or creates a unique and interesting surface.

Sennelier semi-absorbent gesso

By giving the canvas a fine grain similar to that of watercolour paper, this gesso forms a porous surface when dry. In turn, this improves penetration and diffusion of the colour with greater resistance to water than traditional paper. It can be used as it is or tinted by pre-mixing it with acrylic colours. It is designed for painting with acrylic, oil (gives a matte touch), watercolour, egg tempera, gouache, or casein. The primer is water soluble and dries rapidly. The manufacturer recommends three thin layers are applied. It can be thinned with water to enhance levelling. It if is thinned extensively, then additional layers may be required.

You can also use it to create added textures with a palette knife. The reliefs capture the colour in the hollows and provide an interesting three-dimensional effect to different details of the composition.

Lascaux gesso

This is a more absorbent variant of Lascaux Primer. It is a pure, white matte preparation with a good tooth. It is elastic, lightfast and age resistant.

The gesso is applied slightly diluted to improve brushability. On unsized textiles, Lascaux Gesso should be diluted 1:1 with water for the first coat. After approximately four to six hours a second coat may be applied. Between the two coatings, uneven fibres and knots can be flattened with a fine abrasive paper. Coated fabrics can be rolled. The following coat can be diluted with 25 per cent of water and can be tinted with acrylic colours.

Ara gesso

Ara gesso is a universal primer for oil, acrylic, watercolour and tempera. It can be thinned with a maximum of 20 per cent water. Allow to dry for three to four hours between layers. It offers value for money for a professional grade gesso and is available in one or 2.5 litre sizes, so if you are planning to paint large pieces this may be of interest. It also offers high adhesion factor and great tinting strength and gives elasticity, a toothy surface and is semi-absorbent.

Testing the grounds

To help compare the grounds designed specifically for watercolours, three layers were rolled onto a piece of black mount board. This allowed the opacity to be compared. A final fourth coat was brushed across the bottom of the card to show what full coverage looked like. It should be noted that rolled layers tend to be thinner and more even than brushed ones.

Most framers will be only too happy to get rid of off-cuts of mount board. Regardless of colour, these make excellent practice pieces so you can get used to working on the semi-absorbent surface before moving onto canvas.

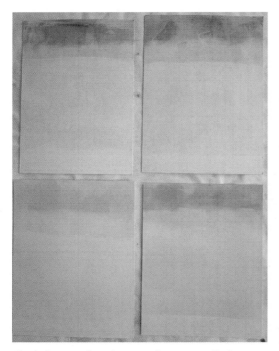

Three layers of each ground were applied to black mount board. You can immediately observe the difference in opacity. Top row Schminke (L) QoR (R), bottom row Daniel Smith (L), DIY (R).

To test the performance, different techniques were used. First pigment was painted on and diluted on the single, double and triple coating. Wet in wet application tested how the paint moved. Glazing was tested by brushing pink and Sienna over dried gold. A rigger was used to see whether there was any bleeding on a dry surface. Salt was applied to a purple wash. Colour was dropped into a damp wash and lifted with a damp brush and Magic Eraser indicated how well the ground gripped the pigment. This is not meant to be a rigorous scientific analysis, but designed to show that each preparation has its strengths and shortcomings.

Schmincke

This German manufacturer produces a fine watercolour primer and coarse watercolour primer in white or transparent. The grounds may be tinted with tube watercolour, gouache or acrylics. Fine and transparent ground is avail-

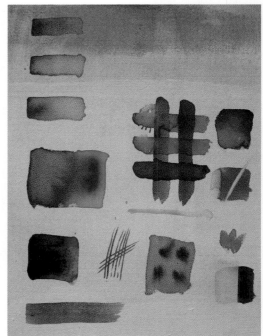

Schminke.

able in 250ml or 500ml pots, while the coarse comes in a 300ml or 500ml jar.

The fine ground can be applied very smoothly if care is taken and while the coarse is harder to spread, it will give a surface not unlike a rough, handmade paper once dry.

The transparent ground allows the surface to remain visible and can be used to 'fix' your painting if you are finding glazing an issue.

Limited instructions for use are on the packaging, but the manufacturer recommends applying at least three layers of the fine primer with brush or roller. Equipment should be cleaned with water and soap immediately after use. The coarse primer can be applied with a spatula in one layer. All should dry thoroughly overnight before being painted.

Schmincke also produce two modelling pastes specifically designed to use with watercolours. These allow three-dimensional effects and should be applied with a spatula and painted over once dry. These could be used to make your own semi-absorbent ground.

Personal observations

The large, squeezy bottle makes applying the ground evenly quite straightforward and will suit those preparing larger canvases. It is a relatively thinner preparation, which gave the first coat the poorest covering power of the four compared, however, after three coats it seemed to have caught up.

The watercolours took the longest to dry on Schmincke ground, meaning that wet in wet techniques worked well and the paint stayed workable for longer. It did mean that the addition of salt had little effect, as the paint was too wet and dropping clean water into a wash did not form blooms, as it was still workable. Paint lifted easily both with a damp brush and with Magic Eraser. Wet on dry edges were crisp and softening them off was tricky without lifting all

the paint. Glazing was not that successful. It feels that the ground does not grip the pigment firmly.

Conclusion: Most suitable for people wanting to work on a larger format and using wet in wet as their main technique, with only a very limited need to glaze unless you use additives to fix under-layers.

Daniel Smith

Daniel Smith is an American manufacturer known for its range of fine watercolours. Its Watercolour Ground is available in White, Buff, Black, Transparent, Pearlescent White and Iridescent Gold. As the grounds can be coloured with watercolour, acrylics or gouache, the point of tinted grounds for the watercolour artist is a little unclear. Black would be exciting for mixed media and other water-based applications, but has little obvious use for watercolourists.

Daniel Smith says that a neutral or tinted-

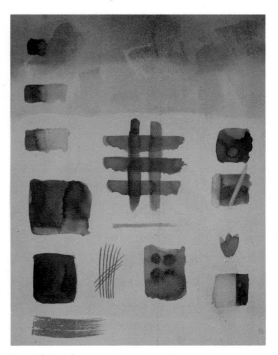

Daniel Smith.

base colour will set the mood and atmosphere for your artwork. Should you be painting on another surface and not a canvas, then tinting allows you to match your painting foundation to that object, creating an invisible surface.

The manufacturer recommends that non-absorbent surfaces should be sanded before application. It says that one coat may be enough on an absorbent surface such as canvas. In practice three coats give a good level of absorbency. Full drying time is given as 24-72 hours and they do not recommend heating to speed this. The primers can be diluted with up to 10 per cent water to enhance the smoothness of application.

Personal observations

The Daniel Smith ground has the greatest covering ability of those tested. Visually it covered the black card in three coats, so that the fourth made little difference.

In performance it felt close to that of paper.

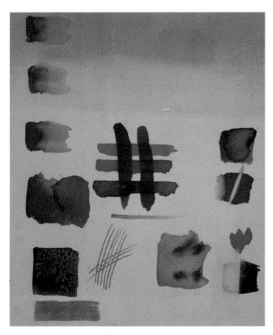

QoR.

The salt texture worked well, the pigment moved to form a bloom when water was dropped into a damp wash and edges of the rigger lines stayed sharp. Colour lifted cleanly with both a damp brush and Magic Eraser. Glazing, while better than on the Schmincke ground, was still hard to achieve.

A major downside to the Daniel Smith grounds is that in the UK they are only available in 118ml jars (4 fluid oz). In North America they are available in pint pots, which given that you may wish to paint on a larger scale, seems far more practical.

Conclusion: This ground is a good choice for those wanting to work on smaller pieces and who are looking to keep as close to their established technique as possible.

QoR/Golden

QoR is the watercolour brand from Golden. They claim to have brought watercolours into the modern age by using a new binder Aquazol® rather than gum Arabic.

Golden produces Hot Press Watercolour Ground, Cold Press Watercolour Ground and Light Dimensional Watercolour Ground in 237ml pots. These allow you to create a smooth or more textured surface.

QoR Watercolour Ground transforms almost any surface into an absorbent, bright white painting surface similar to hot-pressed paper. The smooth surface remains flexible with a soft feel. The manufacturer recommends allowing twenty-four hours or longer to fully dry before applying paint washes. Two or three layers are required and the primer can be thinned with up to 25 per cent water to aid a smooth application

QoR Cold Press Ground creates an absorbent, cool white surface with the appearance of a toothy Not/cold-press or rough handmade paper. It is applied using a palette knife or

spatula. A smoother finish can also be achieved by skimming with a wet palette knife during application. Allow the layer to fully dry. Thicker applications may take several days before they are ready to be painted, however, it is ideal when a rough texture is desired for emphasizing dry brush techniques.

Golden state that their Absorbent Ground can be used to prepare canvas for watercolours. It is an acrylic liquid surfacing medium that create a porous, paper-like surface when applied over gessoed canvas. Though it is available in larger pots (946ml which is tempting for a more prolific artist), experience shows it does not respond as well as the QoR grounds and I would not recommend using it.

QoR Light Dimensional Ground can be applied smoothly and thinly, and built up to create interesting textures. It is an extremely absorbent surface which allows washes to spread quickly. It is non-levelling and will retain tool marks. Thicker applications may take several days before they are ready to be painted.

Personal observations

The QoR ground was thin and creamy and struggled to visually cover the black card; the fourth layer made a big difference.

The paint dried noticeably faster than on the other grounds. This means that the wet in wet work was not successful, the salt did not move the pigment and dropping clean water into a damp wash did not form an irregular bloom, simply a circular mark. The colour dropped into a wet wash, developed feathery edges, but did not move far. The paint did not lift as easily with a damp brush and there was more staining left after the purple was lifted with a damp Magic Eraser. Glazing seemed more successful than on the other grounds, with the gold underneath layer showing, optically mixing with the pink and Sienna top layers.

Conclusion: It would seem that the QoR ground is more absorbent than the others, making it suitable for those who want to make glazing part of their process. The artist will need to work quickly to catch the paint at the optimum dampness, but potentially will not have to wait so long for areas to dry.

Make your own

You may find it hard to locate some of these products depending on where you live, but the good news is that you can make your own watercolour ground using more readily available art materials. It will behave differently from the commercial grounds, but is very cost effective and certainly does the job.

The recipe is simply three parts white gesso mixed very thoroughly with one part acrylic-modelling paste. Any good quality gesso and modelling paste will work. More expensive gesso will be more opaque. Beware that not all acrylic modelling pastes dry white and would there-

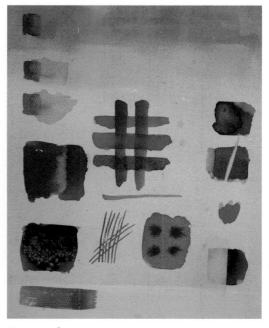

Homemade.

fore tint your homemade ground. The mixing is important as the paste is by its nature very thick. It should be stored in an airtight container.

It may be thinned with 10 per cent water to improve levelling and three coats are required to prime the canvas.

Personal observations

The DIY ground tested was made using Galleria Gesso and Modelling Paste. Given that there are potentially an infinite combination of gesso and pastes available, these results are not conclusive, but they show that the DIY ground compares favourably to the branded preparations.

The opacity was the worst of the four grounds tested. After three layers it needed a fourth to really cover the black. However, performance-wise, it did well.

The colour did not dry so quickly that wet in wet effects were not possible, though they were not as smooth as the QoR surface. The colour lifted with a damp brush and eraser in a similar way to Schmincke and Daniel Smith. The glazing performance was second only to Daniel Smith and the way the pigment reacted to clean water and salt was on par. Edges appeared to be crisp when painted wet on dry.

Conclusion: Though the DIY recipe might not have the paper-like qualities of Daniel Smith or the glazing qualities of QoR or the wet in wet of Schmincke, it is a good option for those looking for a semi-absorbent ground on a budget or due to local availability.

Why not just paint with acrylics watered down?

It may have occurred to you that you could achieve much the same effect, with less hassle just painting with watered down acrylics on canvas. You will not gain the same luminosity or delicacy that pure watercolours give. What you may not be aware of is that by adding more than 30 per cent of water to acrylics, you weaken the polymer binder to such an extent that it will not form a strong bond with the canvas surface. Though it may seem all right at the time, the longevity of the painting is far from certain.

Coarse ground

Rather than comparing coarse grounds (only QoR and Schmincke manufacture them), the method of application can be compared.

Here, one layer of QoR's Cold Press Ground was applied to a dark blue mountboard scrap with a palette knife. The paste is very thick and appears granular, though rubbing it between fingers reveals only a very fine graininess. It covers well in one layer, though you would need to put it on very generously to achieve full coverage.

It is extremely difficult to apply smoothly and all tool

QoR's Cold Press ground is applied with a knife and can be smoothed or deliberately left rough. Left sample smoothed with a roller, centre smoothed with a wet knife and right left with knife marks.

marks remain. In order to level it, a fine roller was run over the surface of sample 1. A wet palette knife was used to smooth the second piece as far as possible, while the third was applied with the palette knife and left. In appearance the rolled surface was similar to a Cold Pressed/ Not surface. The second was equivalent to a very rough paper and the third was unlike any paper surface encountered! It took a long time to become touch dry and was dried for twenty-four hours before use.

Rather than testing the surface in a controlled way, three small tree studies were done of these postcard size pieces. This surface is very abrasive and brushes will inevitably be damaged in time. Dry brushing, wet in wet and glazing all seemed to work well on the rolled surface. Wet in wet was delicate on the middle texture and glazing seemed no problem, though the texture was intrusive. Lifting was less easy than on the fine ground. The texture on the untouched piece was very hard to work over, however, if the canvas is prepared with the end composition in mind, it is likely that some intriguing effects would be possible. Whether this would still be watercolour or closer to a mixed media piece is open to debate. A single layer certainly proved to be absorbent enough to work on.

Conclusion: Both application and use were more challenging than for the fine watercolour grounds, but it does offer intriguing possibilities for those who like to work on a more demanding rough paper and is perhaps best suited to loose landscape work.

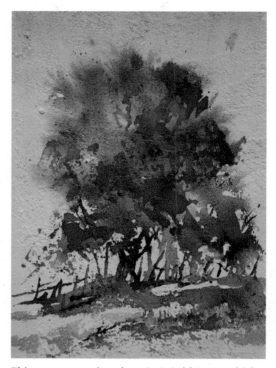

This tree was painted on QoR Cold Press which had been smoothed with a wet knife.

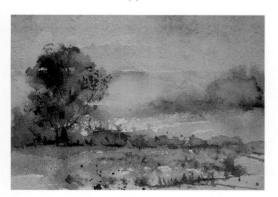

These postcard size off cuts are a good way to test the different surface textures. This is a QoR Cold Press ground smoothed as much as possible.

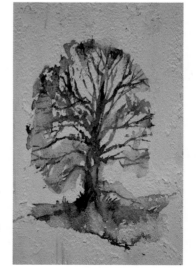

A winter tree was painted on this rough finished QoR Cold Press.

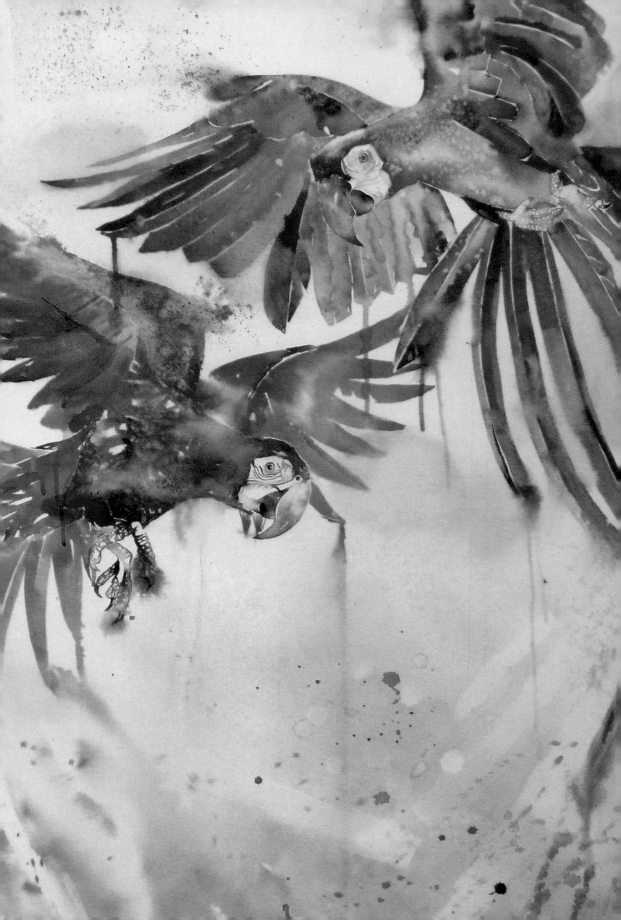

ALL YOU NEED TO KNOW ABOUT CANVAS

If you are an experienced watercolourist or new to the medium, canvas may be alien territory to you. If you have painted in oils or acrylics you may already be familiar with its properties and some of the things which can go wrong with this type of support.

The two components of a canvas are the stretcher bars, which will vary in depth and quality and the support which may be linen or cotton. You will also wish to consider the primer used if any.

When buying your canvas take into account:

- Cotton or linen
- Deep edge or standard profile
- Off the shelf or bespoke?
- Size and shape
- Quality versus cost.

Cotton or linen

Canvas is the catch all description of the material support – cotton and linen are most frequently used. Cotton duck canvas is the most common and cheapest variety of canvas, but it still comes in different weights and weaves. Linen has a smoother finish, with finer threads and a tighter weave. It's better for paintings with fine detail which might otherwise be obscured by the texture of the fabric. Synthetic fibres are available, but their long-term durability is not certain.

Budget canvas is generally lighter in weight with thicker threads. More expensive canvases will have finer threads with a denser weave, making them heavier. The heavier the weight of the canvas, the more robust it is. While most paintings will not be kicked around during their life, the fabric is under tension, especially around the edges. Larger paintings may be under considerable stress so you will want to go for heavier weaves if you are aiming for large-scale images.

Cotton fibres are shorter and stretchier than linen, which is a much longer strand and stronger fibre that offers less flexibility. The advantage to cotton canvases is that they are easier to stretch as a result, and are more affordable.

Linen's better strength and durability offers mould and mildew resistance as well, since it is not as absorbent as cotton. Linen also retains its natural oil content, which preserves the fibre's long-term flexibility. Cotton canvases (especially large ones) can become slack due to stretch with the weight of heavier paints and an increased surface size, requiring either the use of canvas keys or re-stretching the entire painting. However, linen is a more expensive option.

LEFT: **Flight of Fancy, 95 x 95cm, watercolour on canvas.**

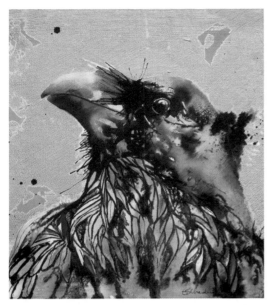

Small deep edge canvases are perfect for experimenting on. This raven was painted (after a visit to the Tower of London) in ink, watercolour and finished with gold leaf. It is 25 x 25cm and the image continues around the side.

Deep edge or standard

Deep edge canvases are contemporary and fashionable at the moment. If you continue the image around the sides, or paint the edges of the canvas, no framing is required. If you plan to frame the final piece, then what you save on the cheaper smaller profile might go towards that expense. It is a matter of personal taste.

Off the shelf or bespoke

If you are looking for an unusual size and a particular weight or finish to the canvas, you can order a bespoke canvas. These are things of beauty and are wonderful to paint on. You will get exactly what you want, but at a price.

Off the shelf, it should still have neat edges, robust stretcher bars that are up to the job, and canvas which does not sag the moment you unwrap it, however, you will be able to tell the difference both in terms of performance and price.

You could stretch your own, which is economical and flexible. However, to start with, you will probably simply buy cheap canvases off the shelf, until you are ready to push your work to the next level.

Cost versus quality

Cheaper canvas tends to have a coarser weave and be on narrower stretchers. Check to see

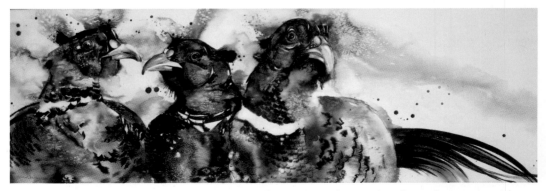

If you require a specific size canvas, you may need to get it made to order. These pheasants are 170 x 50cm and from the collection of John and Sarah Brookshaw. The bespoke canvas was a joy to work on.

WHAT TO LOOK FOR IN THE PERFECT CANVAS

- Check for warping – lay the canvas on the floor and ensure that all four corners touch the ground.
- Look for expandable joints and keys/wedges, so that if the canvas sags over time you can easily tighten it.
- Look to see if the grain of the canvas is parallel to the edges. If it is at an angle, it is a sign of a poorly constructed piece which may distort over time.
- The stretcher bars should be made from kiln dried wood. This is wood that has its moisture removed so there will be less room for the wood to distort over time.
- Check that neither the stretcher bars nor cross braces are split or have large knots in the wood which may become a weak point.
- Unless you're working really small, the canvas weight to look for is 12oz or 390g/m². This means you can pull tight without the fear of ripping the material.
- Standard primer or gesso serves to protect the fabric and helps the paint adhere to it. The paint sits on top of gesso, it doesn't soak into the fibres. Though you are going to add extra ground, it will save you time if the canvas you buy is already primed with at least two layers of gesso.
- Look for cross braces on larger stretchers. If they are absent the stretcher bars may bend in the middle when pulling hard to achieve a tight canvas.
- A canvas should be taut with 'bounce'. It will flex as you paint on it and add a rather nice rhythm to your painting process.

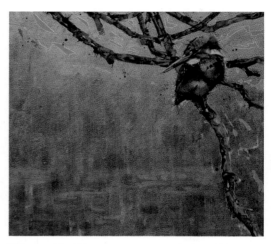

Using a 90 x 90cm canvas gave plenty of space to explore the peaceful environment of this small kingfisher.

that the canvas has been pulled straight as it's been stretched, that the threads run parallel and aren't skewed, and how neatly it's been folded around the edges and attached. Also check that the primer has been evenly applied, that you can't see any raw canvas.

So, what canvas should you use? Initially, anything that's neatly made and cheap. Then a bit later try out a few other brands, with heavier canvas as well as a finer weave, to see how they compare. It's a question of finding a balance between cost and feel of the canvas, ultimately a personal decision. I generally use a cotton canvas with a fairly tight weave, but I do also keep an eye out for sale bargains. The size and proportions of a ready-made canvas are more often what determines what I buy, rather than brand.

All you need to know about canvases but were afraid to ask

If you haven't spent much time around canvas you might not know how to deal with common problems. A dent, sagging or even a rip – there

is no need to panic. And remember that most problems can be avoided through careful buying and storage.

Storing canvases

Store canvases vertically whenever possible. You can store them face to face or back to back to minimize denting. If they are stored angled against a wall they may warp over time. If you store them horizontally they may sag and will need to be re-tensioned before use.

Do not store either new or painted canvases in buildings such as garages or sheds. Damp conditions will make them susceptible to mould growth and the stretcher bars may warp. Far better to keep your canvases in a temperature controlled environment such as your home or studio.

Avoid direct sunlight or heat sources. Remember the materials, canvas and wood, are natural and will expand and contract given temperature variation.

If the building is damp, beware of wrapping canvas in plastic, bubble wrap or other storage bags, which may trap the moisture rather than protect the canvas.

Remember that framing your finished artwork can protect a painting and reduce the chances of it warping in the future.

Rolling canvases for storage

If you are a prolific painter and storage becomes an issue, you have the option of removing the canvas from its bars and rolling it for more compact storage. You may also wish to consider this if air-freighting a painting. The volumetric weight of the work will be high, compared to the actual weight. Exercise caution as the removal and restretching of a piece brings a risk of damage.

Ensure the painting and any sealing coat is thoroughly dry. Do not cut the canvas off the bars, as you will not be able to restretch to the original size. First, using long nose pliers, gently remove the staples from the back of the canvas. You will now be able to remove the canvas from the bars and the stretcher bars will simply pull apart.

The painting should be rolled with the image outermost to avoid the chance of cracking or wrinkling. Roll the painting loosely and in as big a roll as practical. Store vertically rather than horizontally to avoid stress on the painting. Ideally wrap the painting with an unpainted piece of canvas to protect it. Do not use bubble wrap as the texture may imprint on the surface. Plastic may stick or cause condensation issues.

Store a rolled painting for as short a period as possible. When you unroll it, do so at room temperature to ensure the canvas is pliable.

Mildew

If you store canvases in a damp building or one

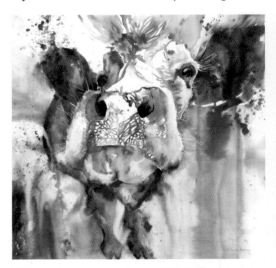

When I started exploring working on canvas, I received a number of donated panels suffering from mould. This cow was painted on one after I had treated the mildew.

subject to temperature variations, you may find yourself staring at mildew or mould. Ideally you should simply throw these canvases away. However, most artists can't bring themselves to get rid of art materials, so as long as the stretchers are not warped you can start by thoroughly drying the canvas. Do be careful as breathing fungal spores is never going to be good for you. A few days' exposure to strong sunlight should kill the spores.

Once dry, brush the stain with a soft-bristle brush and see if that removes some of it.

Some conservators suggest a 70 per cent surgical spirit and water solution dabbed onto the area will kill the spores and remove the stain. Do not use bleach or vinegar despite wide advice to do so on the internet, as these will alter the pH of the canvas and impact on its archival nature. If it is already primed, you may wish to add an extra layer to disguise any staining.

If the mould is on a completed painting, make sure you test an inconspicuous area before undertaking any remedial work and talk to a picture conservator or framer for advice. If you live in an area of high humidity, you may wish to use spacers behind your artwork to ensure air circulates between the wall and picture.

Denting

Canvases can dent easily should anything be stood against them. Luckily, removing the dent is also easy. Spray the back of the canvas using a plant mister or other spray bottle and rub the water into the canvas with a rag. You want to use enough so that the water works its way into the weave of the material. Then press a flat object against the dent for a minute and let the canvas dry. The canvas will become taut and the wrinkle or bump will smooth out.

Another option is to lay the painting face down on a clean thick cotton towel. Then,

using a steam iron held above the back of the canvas an inch or so, lightly release steam onto the dent or wrinkle until it is wet (no more than a minute). Wipe off the excess water and then let the canvas dry upright.

You can also use a blow dryer to hasten the drying process and to promote tightening.

Sagging

Wood is a natural material, so over time the stretcher bars can move and distort. This may cause the canvas to sag. Equally cotton can stretch under the weight of primer and paint.

Over time canvas may sag or the corners pucker. Rectifying should be straightforward.

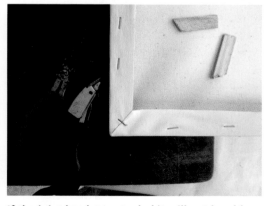

If the joint has been stapled it will not be able to expand, so you will need to remove the old fixing at the corner before driving the pegs home.

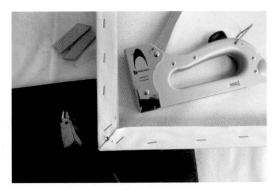

Wooden pegs should be supplied with every canvas.

You have several choices about how to restretch. The first is to shrink the canvas all over in the same way as you remove a dent, by wetting the back of the canvas with a spray and rubbing it in. As the canvas dries it will shrink back and tighten. Potentially the canvas may stretch again, in which case you need to use keys or wedges.

Gently tap the wedges (two per corner) into the grooves at the corners of the stretcher bar and you will gently push the bars apart, thus re-tightening the canvas. If you tap too hard with the hammer, you may tear the side of the canvas. Expanding the stretcher frame can also put unusual stress on the paint lying on the canvas surface, causing it to crack. Place a small piece of cardboard between the keys and the canvas to protect the canvas when you tap the keys into place with a hammer.

If the canvas has been stapled across the corner, you will need to remove and restaple the corners to allow movement at the joints.

If these two solutions fail, then bespoke treatment such as Tight'n'Up™ Liquid Canvas Re-Tensioner could come to your rescue. It is an acid free, archival treatment to tighten up a sagging canvas. It may be sprayed or brushed on to a natural canvas only. If a painted canvas is framed this may be a good option to avoid having issues with the frame size.

The water in Tight'n'Up™ causes the canvas threads to swell, thereby shrinking their length, tightening the canvas. Acrylic binders in the Tight'n'Up™ seep in between the fabric's threads and fibres, and provide extra support to the canvas. When the water evaporates, the acrylic remains in the fabric and prevents the fabric from relaxing to its previously loosened state, thereby retaining the increased tension.

Broken stretcher bars

Regretfully if an external stretch bar breaks, you should discard the canvas. You could keep the material for practice, mending rips or protecting rolled work.

If a cross bracing bar snaps or splits, then you have the option to splint it. Should you wish to sell the piece, it is probably best practice to point out the repair to the potential purchaser.

Simply glue the pieces with wood glue and then use a spare piece of wood on either side of the break and four appropriately sized screws. Fix the splints either side of the break to hold the pieces together. You should be able to do this with the canvas in place and then retention it if required.

Check for split stretcher bars before buying a canvas. If one cracks after you have painted it, do not panic, they can be easily screwed or splinted.

Cropping a painting

While it is easy to take a pair of scissors to a traditional watercolour on paper, should you be unhappy with your composition or if a part of the painting is displeasing – but another is worth saving – then you have the option to remove the canvas and restretch on a different size frame. This is time consuming and does come with the risk of damage, so think carefully before going down this route.

Start stapling the longest side.

Warping, stretching or re-stretching your own canvas

If the stretcher bars warp with time, it may be that the original wood was not properly dried, or it may have been stored in damp conditions. Check carefully before buying a canvas that all four edges rest on a flat surface. If one corner is lifted, then reject it as a bar is warped. You should be able to return an unopened canvas for a replacement, given that it is not fit for purpose.

Should a painted piece warp, your only option is to restretch it. You can also buy watercolour canvas by the metre from specialist retailers (*see*

the listing of suppliers), so at some point you might want to stretch your own.

You will need long nose pliers, a staple gun, canvas pliers or a very strong grip, and a small hammer.

First remove the canvas by pulling out the staples. Use the long nose pliers and grip the long edge of the staple and pull straight out without twisting, otherwise the canvas edge tears or the canvas weave pulls apart, leaving large holes. You could also use a flat screwdriver to lever the staples up.

Try to restretch the piece in a warm room, so that the canvas and primer is pliable. Assemble the new, unwarped stretcher bars and any bracing, making sure everything is square. Place the

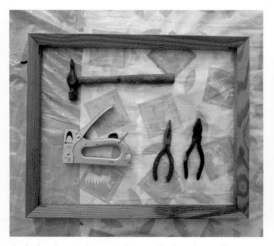

Only basic equipment is needed to stretch a canvas.

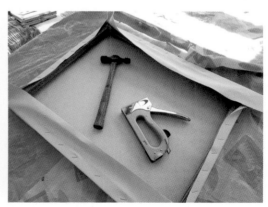

Working from the centre, move out towards the corners.

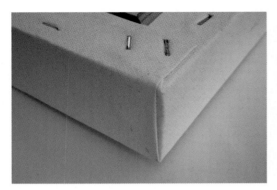

Neat and consistent corners are important.

ABOVE: **The finished canvas needs to be neat back and front.**

LEFT: **You are aiming for a taut canvas with a little bounce.**

canvas face down on a clean flat soft surface, and place the assembled frame on the back so that it lines up.

Staple the canvas in the middle of each side of the material. Start on the longest side, then pull the canvas taut and staple in the opposite side. Repeat with the two shorter ends. You should end up with a diamond stretched in the canvas.

Now work from the centre out towards the corners, stapling every 5cm or so. Use your small hammer to knock staples flush with the surface. Work on one side, then stretch the canvas taut and put in the same amount of staples on the opposite side. Repeat on the remaining two short sides, keeping the canvas tightly stretched.

Examine the corners carefully and decide on how you want to fold them. Make sure each is the same. If you are folding an old canvas, simply use the existing marks and repeat the fold.

Repairing a rip

Sadly canvases, however tough they may appear, can get ripped. If it is an unpainted canvas, discard it. If you are painting in a medium with body, you may be able to fully cover any repair, but this is less likely with watercolour. The time and hassle of repair, coupled with the possibility of an unhappy outcome, simply is not worth it. Keep the bars for a future project, retain the canvas for wrapping other work and move on.

Of course, if it is a finished piece and the hole is not too large, you will want to have a go at repairing it. If you are doing mixed media work, depending on where the tear is, then again you may be able to cover it with collage.

Repairs are made from the back. Make sure the patch is larger than the rip and round off the corners.

Line up the fibres and once dry, fill and apply layers of gesso before painting.

The secret to repairing a tear in a canvas is to do it from the back of the canvas. You will need to match the edges and threads of the tear and use another bit of fabric to hold it in place.

Cut a piece of canvas that is at least a couple of centimetres wider than the tear all around. Round off the corners to prevent lifting. Lay the canvas to be repaired face down on a clean, flat, soft surface. Using an acid-free fabric glue, follow the instructions and apply to the patch and back of canvas. Acrylic gesso or matte or gel medium also works well as glue. Avoid the temptation to apply too much glue – you will end up in a mess.

Now turn the canvas face up and place a flat object under it, which is the same thickness as the stretcher bars. This will support the canvas while you work. Align the edges of the tear, use tweezers to line up threads. Push these flat into the still wet glue. Try to avoid getting glue on the painting face. If any loose threads remain, simply trim with a scalpel when fully dry. Now protect the face with a piece of paper and place a book on top to sandwich the canvas. Wait until dry.

When the glue is set, you can try to hide the tear under some additional gesso or medium. Even if the canvas is already painted, you can use a small brush to try to add some additional gesso or medium to the tear on the front of the painting to bring the surface up to the level of the original canvas. You may need a few layers. I find the Cold Press ground is good at filling and disguising the tear.

If you are selling the painting you may want to let the buyer know about the repair.

Of course, if the painting is valuable, then an expert will be able to do a far better job and may reline the entire painting. If in doubt, please check with an expert.

Use an acid free adhesive.

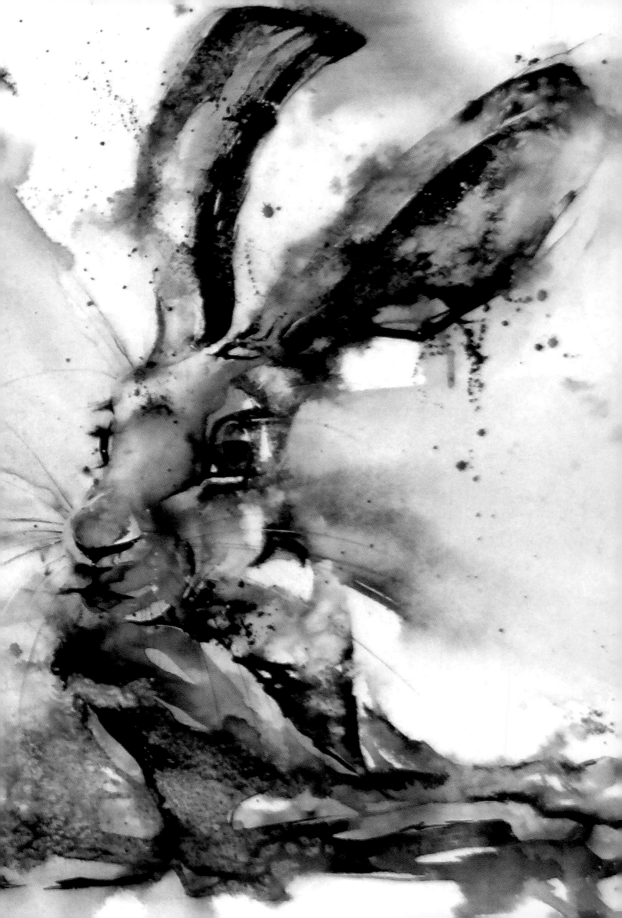

GETTING STARTED

Surface preparation

Select your canvas, taking into account the texture of surface you want – smooth or rough, a fine weave or a distinct pattern of fibres.

If you have stretched your own or purchased an unprimed canvas, you will need to apply two coats of acrylic gesso. This protects the fibres.

Select your ground to achieve the end effect you want – take a look at the recommendations in Chapter 1. Consider if you want a smooth or rough surface and how much of the canvas surface you want to show through. As the coarse ground is both more challenging to apply and to paint on, start your experiments with the fine ground.

Make sure that you protect both your work surface and yourself. As a watercolourist you may be blasé about the washability of your chosen medium. However, semi-absorbent ground is designed to stick to pretty much anything and therefore you need to be a little more cautious than usual.

ing brush, a sponge brush or a roller, to prevent brush marks from showing. Whatever you do, do not use your watercolour brushes.

Thin the first coat of ground with 10-25 per cent of water depending on the manufacturer. This will ensure levelling and keep brush marks to a minimum.

To ensure an even coat especially on a larger surface, place a portion of the ground at 20cm intervals across the canvas and then using diagonal strokes, spread it out to cover. Now use even vertical and horizontal strokes to ensure every fibre is covered. Hold it against the light to see which areas have not been touched. Then with a light stroke brush across the entire surface edge to edge. Allow to dry. Depending on conditions this will take a couple of hours.

Don't forget the edges if it is a deep edge canvas and be careful not to get thick patches at the edges where it catches your brush.

You can sand the ground-prepared canvas using very fine wet and dry sandpaper in between coats to achieve a smoother finish.

Fine ground

Apply the ground following the manufacturer's directions. The more coats you apply, the better the absorbency. Though some may suggest one coat is enough, generally three thin coats work well. You may use a good quality decorat-

LEFT: **Reclining Hare. Detail originally 100 x 100cm ink and watercolour on canvas. From the collection of John and Sarah Brookshaw.**

To ensure an even spread of ground, place equal and regular amounts of the primer across the surface before spreading with a brush or roller.

Multiple thin coats are better than one thick covering, so repeat these steps to build up the layers. Let the prepared canvas dry for at least twenty-four hours. If you paint on the canvas before it has cured, the ground will lift.

You may find there is a slightly chalky residue. If so, wipe with a damp lint-free cloth. Likewise, if you have prepared and stored your canvas, you may wish to wipe over the surface with either a damp cloth or even with rubbing alcohol to ensure it is grease free. This will also stop any resistance to the first wash which you may experience.

As you gain confidence, you may wish to let the ground play a more dominant part in your end painting. You can allow the brush strokes to show through, though to ensure they complement your final image, planning is required.

Coarse ground

If you wish to achieve a ground similar to a

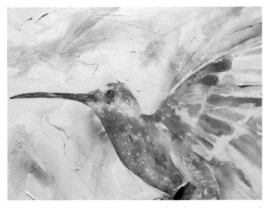

The ground for this humming bird was prepared with QoR's Cold Press applied in one layer with a knife, leaving bold tool marks. The area where the bird was to be painted was left smooth and prepared with ordinary ground. These were different shades of white once dry, so a coat of Daniel Smith's pearlescent white unified the two. It made for a very interesting texture, but it was extremely tough on brushes.

rough, handmade paper, the process is slightly different.

Ensure the canvas is primed with gesso first, as before. Now, following the manufacturer's instructions and using either a spatula or palette knife, apply a layer of the paste. It should not be thinned. Any brush or implement marks will be retained by the thick paste. Should you wish a texture akin to a rough paper, you will need to smooth using a wet palette knife or you can roll over the surface to achieve something closer to a Not/Cold Press surface. As you become more experienced, you could build a deliberate texture to reflect the composition you plan.

Leave to dry for at least twenty-four hours.

Cleaning up

Wash all tools straight away with soap and warm water. Semi-absorbent ground is designed to stick to any surface, so it ruins brushes. Don't wash leftover ground down a sink – it will block your pipes. Excess ground can be stored in an air tight container.

Preparing canvases doesn't take long, it is the drying which takes the time. You should be able to get three coats onto a canvas in a day and let

Much as you think you will remember, mark the back of each canvas with which ground you have used and how many layers you have applied.

it dry fully overnight, if you have a warm and dry atmosphere. So it makes sense to prepare a number of canvases at once. If you do this and store them for future use, it is worth noting on the back of the stretchers in pencil what you have used to prepare them and to mark off the number of coats. You may think you will remember, but in the excitement of trying out new effects and ways of working, it is inevitable that you will forget and mix part-prepared canvases with unprepared. Once dry, the semi-absorbent ground is hard to distinguish from a gesso-only canvas, so it is far better to avoid confusion.

Currently, only Daniel Smith produces coloured grounds, but tinting your own is easy with gouache, watercolour or acrylic.

Have a play

Canvases are perceived as expensive to experiment with, though if you compare them with a sheet of good watercolour paper, there is not much difference. However, this perception may inhibit the spirit of experimentation and learning.

My solution is to talk nicely to your local framer and they will give you the off cuts of mount board from the middle of mounts. The colour is irrelevant, as you will prime them with the semi-absorbent ground. If you prepare these boards, you can practise brush marks, explore the lifting capabilities, see how absorbency increases with layers, all without fear of ruining a 'proper' canvas. You will not experience the 'bounce' of working on canvas, but the ground will behave in the same way and you will build understanding and confidence without inhibition.

Key techniques

Arrange your workspace

Have everything to hand and ready. You do not want to be in the middle of a wash when you suddenly realize your paper towels are elsewhere. If you are right-handed, having your paints and water pots on the right will diminish the chances of accidentally dropping paint and water on your canvas. Given that the washes are more vulnerable than on paper, you will wish to avoid such accidents. Obviously if you are left-handed, arrange your materials in the

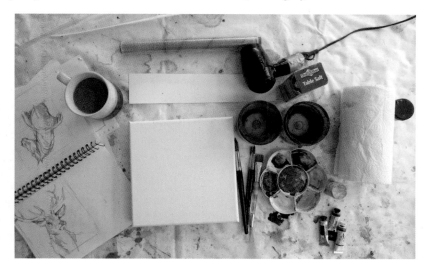

Arrange your workspace so you are comfortable and have everything to hand. Have your thumbnail and reference material, any texturing items, paints and palettes. Keep drinks far away from water pots.

opposite manner. Should you have a drink to hand, keeping it on the other side from your water pots will keep the potential for dipping your brush in your cup of tea to a minimum.

Wipe over your canvas

As noted before, a chalky residue can be present after the canvas has dried. A wipe with a damp cloth or rubbing alcohol ensures the surface is grease free and ready to use. It must be perfectly dry before painting.

Work flattish

To allow you to control the flow of paint on your surface, your canvas will need to be painted flat, or at a slight angle of about 10 degrees. Simply prop the top edge on a thick book and

this slight angle will help you control the flow of water. You will immediately realize that the length of your arms restricts the size of canvas you can work on.

A vertical canvas is a recipe for many dribbles, so unless you will want to incorporate this into your signature style (*see* Susan Miller in Chapter 7), working at an easel is not an option until you reach the drier, more detailed stages of the painting. You could of course work on the floor if painting very large is important to you.

The drying time is lengthier and you will not want to move a wet canvas and risk upsetting your washes, so make sure your work space won't be disturbed.

To sit or stand?

Watercolourists tend to paint sitting, but the extra energy that comes to your painting when

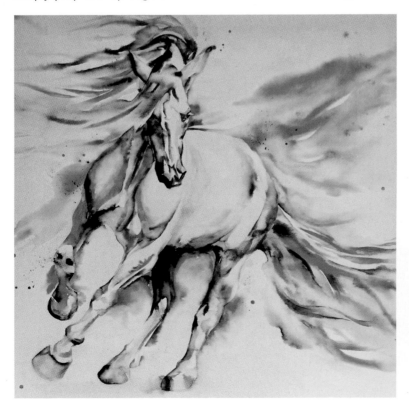

The energy you can capture by painting standing up may surprise you. When working on a larger scale (this horse is 90 x 90cm), planning your work order will really help.

standing, is striking. If you paint sitting and holding your brush as a pen, the movement comes from your fingers and wrist. If you hold your brush towards the end of the handle, you sacrifice precision but by using your whole arm it creates excitement in your marks. Should you stand, then your whole body is involved in the painting process. Many artists aspire to paint more loosely, and standing can certainly encourage a broader sweep of the brush.

Plan

You need to plan your composition more than usual. On paper you can adjust the composition through cropping. Edges (along with mistakes) might hide under a mount, but on a canvas it's all on show so you need to know where you are going. As layering is trickier on canvas, you will wish to get the depth of your tones right from the outset. It is worth doing a series of thumbnail sketches both to assess potential compositions and to ensure you have a good range of tones planned. *See* the next chapter for more on composition and planning.

Consider the canvas edges

If you have selected a deep edge canvas, do you want to continue the painting on the edge? Will you use a frame to hide it or will you leave it white or paint it a neutral colour? Consider this at the beginning, not as an afterthought.

Draw your image

Keep the lines light and to a minimum unless

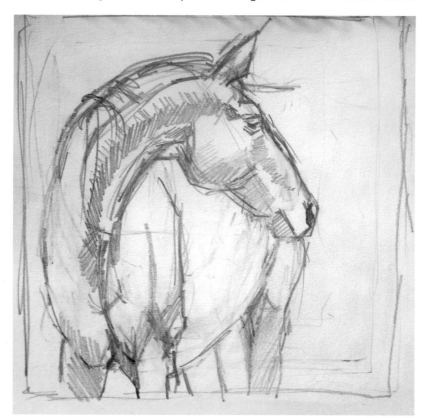

Planning your composition is important. A thumbnail sketch helps you think clearly about what you want to achieve.

you want them to show in your final piece. On paper a harder pencil is in danger of scoring the surface, but this is not an issue on canvas. You can therefore use a 2H or so to keep the lines very light. You will find that the canvas wears down the point of your pencil rapidly, so a propelling pencil is a sensible choice.

If you need to erase errors, a kneaded putty rubber or ordinary eraser is not as effective as a damp Magic Eraser. It will be impossible to remove pencil lines once the first wash is down, so keep marks to a minimum. This will also let you paint in a looser, more spontaneous manner.

You could use a watercolour pencil, so that the guidelines will melt into the wash, or draw with diluted watercolour (non-staining) as an aid to placement.

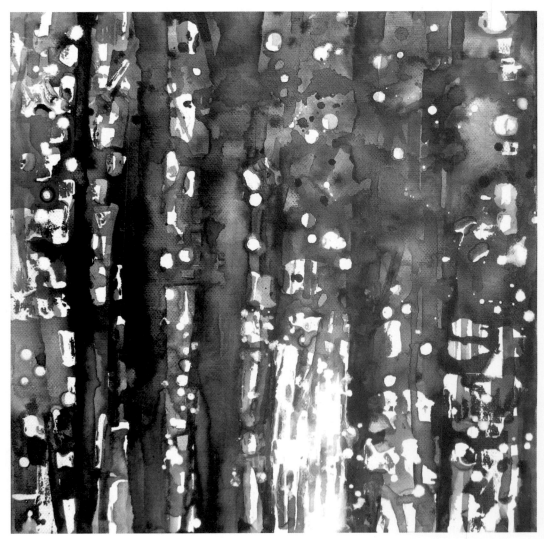

This painting was all about trying to capture light coming through trees in a fairly abstract way. Planning on how to keep whites was crucial and Aqua Fix was used in the initial underpainting to stabilize the pigment.

Consider your whites

Though lifting out on canvas is very success-ful, it is always sensible to consider your whites and light areas. You may wish to apply masking fluid, masking tape or wax resist. There is no danger of masking fluid tearing the surface, but you may find the paint seeps under the edge of masking tape. Ensure the masking fluid is fully dry before painting to avoid contaminat-ing your brushes. Of course gouache or even further white ground could be applied for high-lights at the end.

What size brush?

Select a brush which feels slightly too large for the area you are painting. The natural tendency is to use too small a brush and that encour-ages tight painting. In general, starting with a large brush and moving progressively smaller as the painting progresses will help overcome the need to put in too much detail too early. Your first mark is often the best, so try to touch the surface only once with your brush. While dabbing on paper will lead to muddy colours, on canvas you may find that repeated passes prevents a smooth wash. Use your large brush until the painting is nearly complete then move to a smaller round or a rigger for finer shapes and lines.

Drying time

Paint will only dry through evaporation on the canvas, so you must allow a little longer drying time if you want to avoid any bleed-ing between colours. You can use a hairdryer to speed things up, but keep it moving and do not simply blast a puddle of colour unless you want an explosion. Of course, if you want to achieve a wet in wet technique then you can

do so very easily and over a longer period. You will want to exploit this effect in your work and should not find that the water pools if your canvas is taut. You will need to plan your order of working to take the drying into account and to avoid dragging your arm through a wet patch.

Adjust the amount of water you are using if you find that the drying times are excessive. You may also need to thin the water/pigment ratio to avoid being garish – colours are brighter and more luminous on canvas. If you want to paint with weaker colours, then try adding some gum Arabic to the paint in place of water, to weaken the colours, and this will also 'wet' the canvas better.

Get in, get out, leave it alone

We have already seen that one of the distinct advantages of working on canvas is that the paint lifts easily, allowing you to return to the white underneath in all but the most staining of colours. While this is fantastic for correcting your work, it means you cannot glaze easily without lifting the layer beneath. If your usual method of working relies on multiple glazes you will find painting on canvas immensely frustrating. Life will be easier if you are direct in your painting. 'Get in, get out, leave it alone' is a good mantra to live by.

Do not panic

Remember: if the worst comes to the worst just scrub your canvas underwater and you will be able to remove the offending painting. Do this more judiciously and you can remove an offending section. If there is residual staining, then paint on a further coat of watercolour ground, let it dry for twenty-four hours and start again.

PRACTICAL TIPS

Here's a summary of all the best advice I've been given, which applies whether painting on paper or canvas:

- Paint something simple and well, rather than complicated and fail.
- What attracted you in the first place? Make this your focus.
- Look for the main tones. The greatest contrast will draw your eye so put it at your focus.
- Paint shapes and patterns, not objects.
- Simplify – you are trying to capture the soul of the subject not the detail.
- Make room for imagination; you don't need to resolve everything.
- Do you need a background? If yes, plan it from the start.
- Plan for and use as few colours as possible – six or seven maximum.
- Keep your water clean.
- Mix darks from opposites that you have used elsewhere in your painting.
- Don't use a colour in only one place.
- Get a variety of edges – hard, soft, lost and found – they create interest and movement.
- Stop too soon rather than too late – if you are painting the same section again, you should have stopped a while back.

Lifting/glazing

If there is one thing that artists starting to work on canvas find frustrating, it is that they cannot glaze colours over each other as easily as they can on paper. They find that the bottom layer or layers lift and mix with the top glaze.

While there are some chemical options for getting around this, first you should adjust your work to keep glazing to a minimum. A direct working style means you do not have to rely on repeated layers.

Next make sure the under glaze is truly dry. Use the back of your hand to feel the surface. If it feels even slightly cool, there is moisture present and you need to wait longer. You may need to wait up to twenty-four hours.

Third, develop a light touch – if you need to, use a soft brush with a gentle touch and only do the stroke once over a fully dry under layer.

If these three actions don't help, you can consider adding something to your paint to

help keep it in place. Remember that anything you add to your painting to set the layers will of course mean you cannot lift in the future to fix mistakes. This is a crucial trade off.

If you are struggling to glaze when working on canvas there are a few chemical fixes open to you.

A few drops of Aqua Fix stabilizes your wash, if you plan to glaze.

HOW TO USE AQUA FIX

- Shake well before use.
- Never put directly into pans. Always use a separate palette for mixing.
- Add a few drops to your wash to stabilize it.
- Mix colour completely with Aqua Fix for a water-insoluble film.
- Brush a film of undiluted Aqua Fix over a painted area to seal it.
- Clean tools like brushes as soon as possible with water or water and soap.
- Close immediately after use.
- Store in a cool and dry place but protect from frost.
- Pre-test if you are not sure.

Schmincke Aqua Fix

If semi-absorbent ground is our magic ingredient, Aqua Fix comes a close second. It transforms the water resistance of your paint.

Adding Aqua Fix to your watercolours instead of water lets them dry waterproof, which avoids dissolving of colour when painting in several layers and allows more possibilities for transparent painting. While the manufacturer suggests using it instead of water, a few drops is enough to stabilize the layer as long as you use a light touch. It is best practice to clean your brush and palette thoroughly with water and soap immediately after using Aqua Fix. Lukas Shellac Soap is another possibility. It increases water resistance and creates a buffer for other layers.

Workable fixative

Once you are happy with the layers in your work, you can spray with a workable fixative. This protects the underneath while giving a toothy surface to grip further layers of colour. This is the process that graphite and pastel painters are more than familiar with. You need to find an acid free fixative, which will not repel the next layer, but that is water resistant. The advantage of this solution is that you can seal only the areas you need to fix, rather than adding fixative to all your paints.

Krylon Workable Fixatif is extensively used by artists in North America with excellent results but at the time of writing is unavailable in the UK. Ironlak workable fixative is available.

Personally, I do not use workable fixatives, but some artists prefer the freedom of this route.

Transparent ground

Both Daniel Smith and Schmincke make a transparent ground, so you could use this to seal your underpainting. Another use is that if you have finished but then wish to add to it, you can paint with transparent ground and continue.

Your first layers must be totally dry. You need to use a very soft brush and use only one stroke over the area to be sealed, otherwise you are in danger of disturbing the very paint you wish to protect. This is my least favourite option.

When to stop and what to leave out

Painting requires thought and skill to make something special. Given that it is much easier to add to watercolours than to subtract, take time to consider what to leave out. Having decided how to simplify, be definite in your actions and always remember what attracted you in the first place.

Loose paintings generally omit detail and go straight to the heart of things. Luckily the human eye and imagination likes to extrapolate and fill in the blanks.

Stand back from your work to get a proper view. If you are close and the canvas is virtually flat, your view is distorted. You will only see what your brain thinks is there, not what is really on the canvas. Give your eyes a break, perhaps place the piece around the house where you can catch it out of the corner of your eye and any issues will become clear. Looking at a painting upside down or in a mirror is another classic way of making your brain drop its assumptions and see what is really going on.

Sometimes watercolour has a mind of its own. These happy accidents can bring a paint-

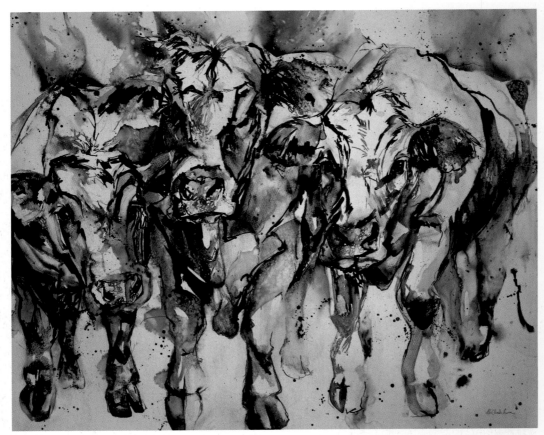

White played an important role in this composition. You will find that what you leave out is just as important as what you put in. *A Tough Crowd*, **120 x 100cm in ink and watercolour.**

ing to life. Perfection can look boring and smug, whereas a few mistakes can appear honest and spontaneous. So when something goes 'wrong' accept it. Trying to correct it rarely improves things.

A monochrome cow

Monochromes are underrated. They are an excellent way of taking out one of the variables and letting you concentrate on key techniques. In this case, removing the issue of hue lets you concentrate on obtaining a full tonal range from the very darkest to the lightest white of the canvas. You will find tone defines the volume, while the colour brings emotion to a piece. The most colourful painting can be bland if every-thing hovers around the same tone, while a monochrome piece can have a huge impact if the tones have been handled with care. If you haven't painted for a while, this is an excellent way to get the creative juices flowing. If you are attempting a complicated subject, a quick tonal study can help simplify shapes and issues, before the introduction of colour.

The source photo, one of many available for free use from Pixabay, was selected because the subject appeals and it has strong lighting. If you struggle to see tones, most phones and tablets have filters to make a photo black and white. While this will help train your eye, don't over rely on it, as when you come to paint from life you will need to separate out tones. Learn to differentiate dark hues which are in strong light, from light hues which are in shadow.

Before starting the monochrome, use a scrap of mount board prepared with ground to develop a tonal scale of at least eight shades. Start with 'full fat' colour and lighten it in equal

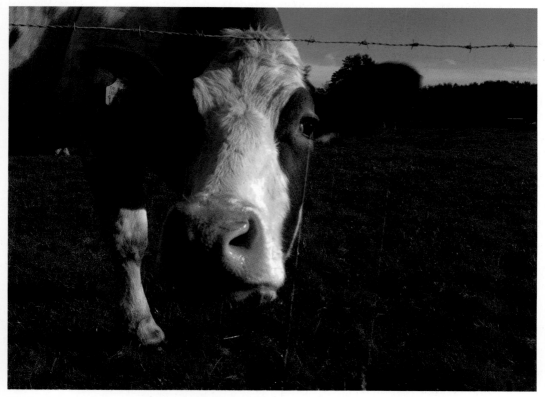

Think of your reference photo as inspiration, rather than something to slavishly copy. (Photo: Pixabay)

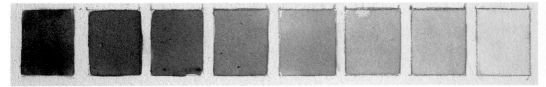

Achieving an even tonal scale is more challenging than you might expect and teaches you so much.

steps until you have a pale tint, or indeed the white of the surface. It sounds so easy, but it is surprisingly tricky to add the right amount of water. This helps you explore the properties of your pigment and come to the realization that controlling the water/paint mix is so important.

Develop a small thumbnail sketch to identify how you will crop the photo, where the main light source is areas of light and dark and to plan your working process, remembering the paint will take longer than normal to dry. This thumbnail should only take a few minutes, and is never intended to be a thing of beauty, but will save considerable time as you proceed. What attracts me to it? For this cow, I like the

whiskers and fringe, so maybe I will emphasize those. Even consider numbering your working order. You can deviate if something interesting happens, but it will give you a map to follow.

Wipe over your canvas if you have any chalky residue or if it has been stored for a while. This is a 30 x 30cm narrow canvas, so I am not continuing the image around the sides. Sketch your subject onto your canvas using a hard pencil and keeping the lines as light as possible. You do not need a detailed outline, simply an indication of main shapes and relationships to guide but not constrict you. If you need to erase any lines, a damp Magic Eraser will remove the lines more easily than a standard rubber. You must make sure the canvas is totally dry before starting to paint. If you are not happy with your drawing, look at it in a mirror or upside down, which will highlight any flaws. Prop your canvas up so you have a slight incline to help you control the water and make sure it doesn't puddle.

The thumbnail is your working plan.

Step-by-step instructions for *Monochrome Cow*

Step 1

I selected Moonglow from Daniel Smith. This is a multiple pigment mix, which separates into subtle greens and reds. You can choose a single pigment or mix your own (ultramarine and burnt Umber or Sienna might be a good choice). The point of this exercise is to get the tones right without having to worry about mixing colour, so if you prepare a mix make sure you have sufficient.

Starting with the eye is a good idea in an animal or person portrait. The eye is always the focal point. If you are not happy with it, you will not be happy with the entire painting so establish it at the beginning rather than the end. It is also good to place a dark early on, as this gives you your full tonal range – like having the capital letter and full stop in a sentence.

Work out from the eye, using a clean wet brush to pull the pigment into areas you want it to flow into. Be very aware of how the pigment follows the water and use it to your advantage. Feel as if you are stroking the cow and follow the growth of the fur. If any interesting marks appear, they will be natural and look intended. If you skip any areas leaving the white, they will also integrate with the image if you follow this process. The areas of white in watercolour bring the painting to life, so do not be afraid of them. Think about painting interlocking shapes rather than 'an eye' or 'an ear', this will give far greater coherence to your image. Use a small spray bottle to soften edges, for example, here on the ear.

Step 2

The left section may be quite wet, so leave it time to dry by moving to the right eye area. If you are left-handed you might want to reverse this to avoid working over wet. Start with the eye and connect shapes, using a damp or wet brush to pull the pigment across the canvas. The right is in the sun, so this area will have more light and mid tones. Think about mark making. Don't always

Step 1: Start with the eye and work away from it.

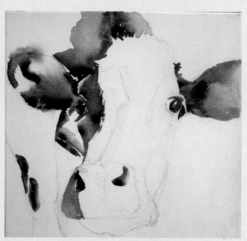

Step 2: Think about naturally dividing your subject into sections so you can be in control of the water on the surface.

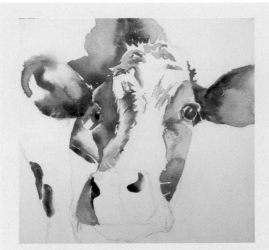

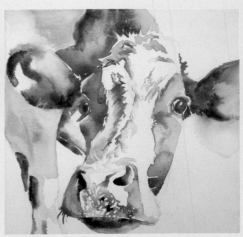

Step 3: Develop a full range of light, mid and dark tones.

Step 4: The leg and back should be kept simple, so as not to take focus away from the face.

use your brush – those little whiskers were formed by pulling the handle through the wet paint and have a different quality than if drawn in with a rigger. It is tiny touches like this that adds interest for the viewer.

Step 3–4

Continue to develop the face and leg. Working in natural sections helps alleviate the effect of the slow drying, but do be aware of what is happening in your previously

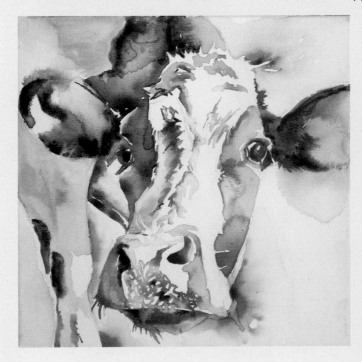

Step 5: Use negative painting and a variety of edges to create interest.

painted areas. Do you need to integrate them? Is an interesting bloom developing? You will notice paint does not dry lighter in the same way as it does on paper, so adjust the pigment mix. Use hard and soft edges. You can use a damp brush or a spritzer to achieve them. You do not have colour to add variety, so make your paint edges do the work.

Step 5

Now use washes in the background to paint negatively, for example, around the cow's fringe. The darker area defines the white. Because glazing is difficult on a canvas, I often keep the background simple to act as a foil for the subject. If you wanted to establish background washes to work upon, you will need to fix them.

Once finished, analyze your painting to your learning. What worked? What could have been better? Use your tonal scale and see if you were successful in getting a full range from the very darkest to the light.

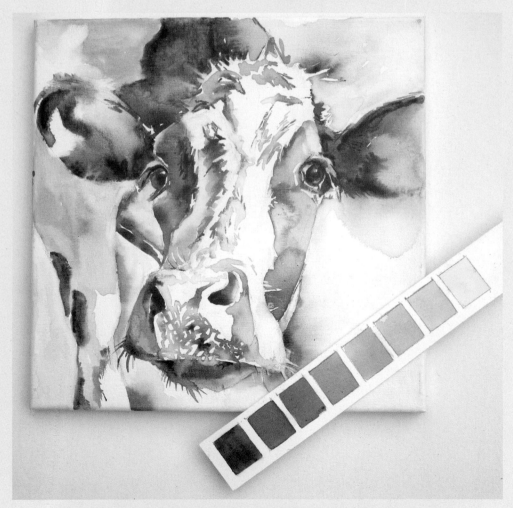

Develop the habit of analyzing your paintings to accelerate your learning.

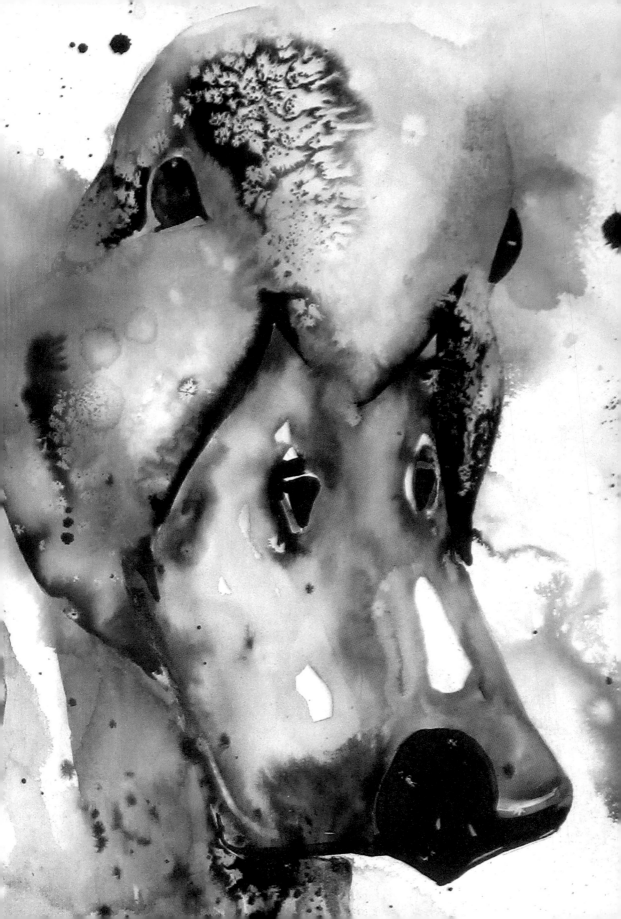

COMPOSITION AND SUBJECT SELECTION

What makes a beautiful painting? Why do some paintings make you want to look at them time and again? Why do others leave you cold? Much comes down to composition.

When painting on canvas it is even more crucial to consider your composition before starting than when working on paper. A good pair of scissors can come to your rescue on paper. If a painting is not working because of poor compositional choices or indeed an unhappy accident, then judicious cropping can often rescue the part that has worked. A well cut mount can hide a multitude of sins. Neither of these luxuries is open to you when working on canvas. If the composition and planning is weak, there is nowhere to hide.

It is amazing how many people simply start a picture in the vague hope that it will turn out all right. You may be desperate to commence, but if you know where you want to get to, the chances of actually getting there increase dramatically. This doesn't mean you can't be spontaneous or take advantages of happy accidents, it just means that if you divert from your plan you do it consciously rather than in ignorance.

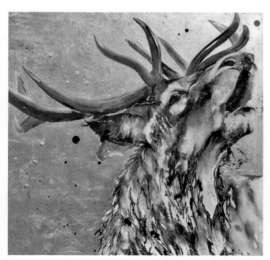

Ink, watercolour and golf leaf on canvas, 60 x 60cm. The placement of the eye, antlers and the vertical down the middle of the neck were done with the Rule of Thirds in mind.

LEFT: *Ducks in a Row*, ink and watercolour on canvas, cropped from 170 x 50cm.

Size Matters. This painting of sparrows is 90 x 90cm and the size says something about the importance of the small and humble bird. I painted a similar image on a 25cm canvas, which resulted in a far more intimate piece.

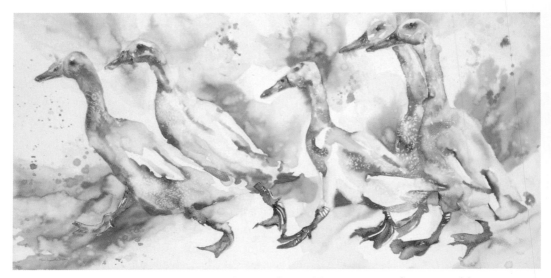

Follow the Leader used a simple colour palette and repetition to create a fun composition.

TAKE A FEW MINUTES TO THINK

- Ask yourself: why do you want to paint this subject? What attracted you in the first place? Make this your focus.
- Decide what format suits your idea – vertical, square or horizontal. Don't always paint the same shape or size painting.
- Consider your scale. Painting a tiny subject on a large scale can say something about its importance that a small picture might not.
- Simplify – now you know your focus, decide what you can leave out and don't worry about accuracy (too much).
- Simplify your painting idea into a few major shapes that will form the overall composition. Large overlapping shapes have greater impact than scattered small shapes.
- Threes work especially well – three objects, areas of a colour, tone or texture.
- Leave something to the imagination and opt for the art of suggestion.
- Consider your background at the beginning not at the end. If you don't need one then work out from the focal point.
- Tones matter more than colour. Identify light, mid and dark tones. If you place the greatest contrast in tones at your focal point it will draw your eye. Don't be afraid of the dark!
- Plan your colours before you start and not as you go along. Use as few colours as possible.
- Try not to use a colour in only one place – have echoes elsewhere. Mix darks from opposites used in your paintings.
- Plan your edges; hard and soft, lost and found – they add a huge amount of interest. Sharp edges attract your eye, so place these at your focal point.
- Aim to finish too soon rather than too late. Once you have captured what attracted you in the first place, then it's probably time to stop.

By asking yourself a few questions, then doing a little planning, the likelihood of being happy with the result increases exponentially.

Guiding principles for composition

These could be called rules, but then you may feel rebellious and wish to break them, so consider these as guidelines which will help to bring balance and interest to your composition.

You will probably know and do much of the following through instinct, but having them spelt out can be so useful when something is bothering you and you don't know why. Being able to articulate what you know through your natural eye will help you get to the heart of the issue.

Golden Mean and the Fibonacci sequence

Whole books have been written about the Golden Mean and it is a fascinating subject, but in keeping with our aim of being practical, what does it mean for you as an artist?

The Golden Ratio, Mean or Section is a mathematical ratio found in nature that can be used to create pleasing, harmonious compositions. It is closely related to the Fibonacci sequence (1, 1, 2, 3, 5, 8, 13, 21...). The Golden Ratio has been in use for at least 4,000 years in human art and design. It can be found everywhere – in classical architecture, natural objects or modern website design. Leonardo da Vinci made extensive use of it in his work.

In the Golden Ratio, a + b is to a as a is to b and is a value of around 1.61. Simplifying it totally, the suggestion is that if you use this proportion and place the focus at the centre of the spiral, you will end up with a beautiful composition. Do not worry that you will need a calculator next time you paint, the Rule of Thirds is a distillation of the Golden Mean.

Rule of Thirds

Imagine that your image is divided into nine equal segments by two vertical and two horizontal lines. The centre of interest should be placed on one of the intersections and other important elements of your composition should be placed along these lines.

Another way of using the Rule of Thirds is to place your main action in four of the sections, leaving the remaining five to frame it, or vice versa.

You can use the proportions of the Golden Mean to help produce a harmonious composition.

A quick thumbnail shows how you might use the Rule of Thirds to place elements within a landscape.

You may also wish to hint at the third lines by subtle changes in tone, colour or texture. You do not have to be blatant about it.

be more dynamic but may be unsettling. If a painting is out of balance it may make you feel uneasy – perhaps this is what you are after?

Balancing elements

If you place your focal point as indicated by the rule of thirds, you may end up with a lot of empty space, so smaller less important elements can be used to balance the composition. Think of a seesaw with one large person sitting on one side balanced by two smaller people on the far side.

You will know when you have achieved balance as it will 'feel right'. Remember that perfect symmetry may feel very calm, but might also be rather dull. Asymmetry might

Leading lines

Our eyes are naturally drawn along lines. You can use these lines to pull the viewer into the picture, towards the focal point or help them journey around the subject. Straight, diagonal, curved – each has a different energy and will enhance your composition, but you don't want them to lead the eye out of the painting otherwise the viewer will move on.

Paths, walls, phone lines are obvious leading lines in landscapes, but areas of the same colour or tone or texture can act in the same way.

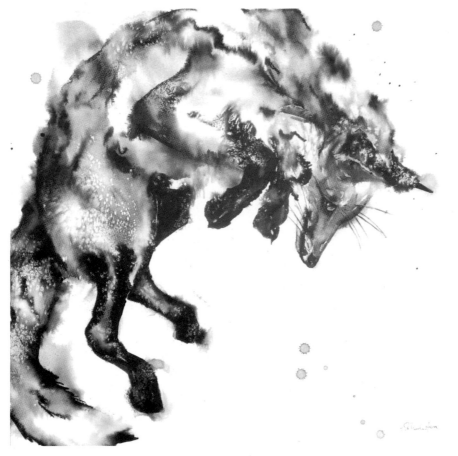

Pouncing Fox **roughly keeps to the outer five sections of the canvas with the head being in the top right centre of interest. I used a few well aimed spatters to add balance.**

Leading lines and framing are quite obvious in this landscape.

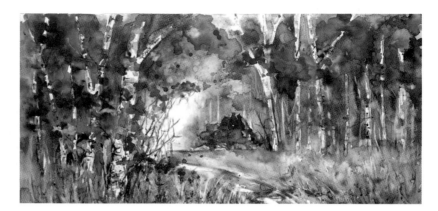

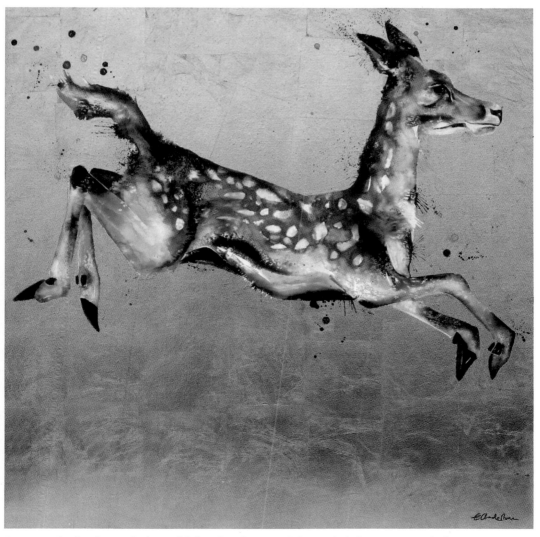

Space can be fun in a painting – this leaping doe certainly needed clear space to 'boing' across. 90 x 90cm, ink, watercolour and gold leaf.

Using a leading line to point to something that is situated at one of the points guided by the Rule of Thirds can produce a particularly strong composition. And don't forget they can also be implied lines.

Other considerations

Repetition

It is good to repeat or echo shapes, colour and tones. Threes and fives work very well as we might expect from the Fibonacci sequence. Fours and sixes can be hard to balance without being boring.

Space

Consider areas of quiet within your composition. If it is too busy the viewer will get a headache, there needs to be a balance of busyness and calm. However, you don't want large areas of boring nothingness.

Viewpoint

Consider your viewpoint. Rather than painting from eye level, consider a worm eye view, or what about a bird's eye view? Try to surprise the viewer and not just do the expected.

Visual framing

The world is full of objects that make perfect

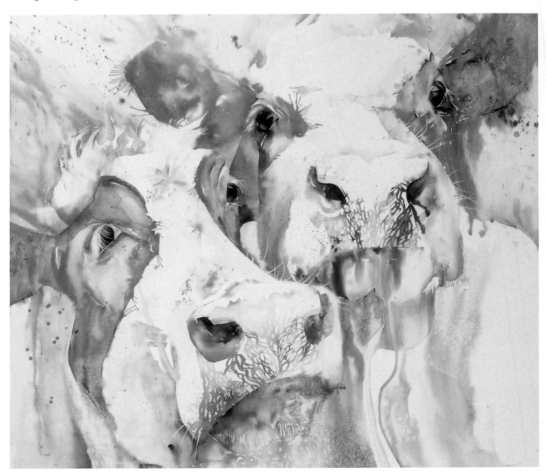

This was my first large scale (90 x 90cm) watercolour on canvas and I used diagonals and repetition to lead the eye towards the top cow.

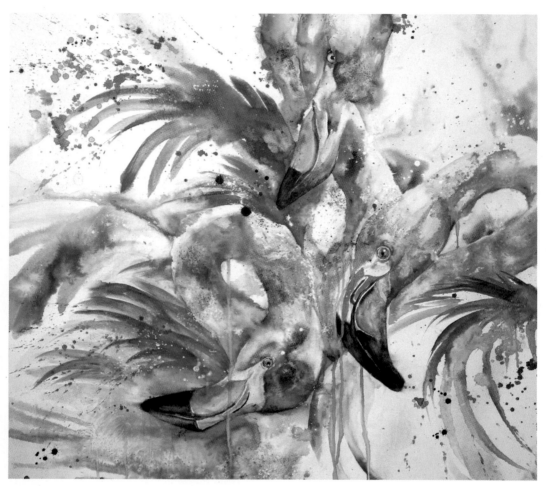

If you compare these flamingos with the blue ones in the introduction, you can see how choice of colour makes a huge difference.

natural frames, such as trees, gates and windows. These might help to isolate the main subject from the outside world, if you place them on the edge of your painting. Such a composition draws your eye to the main point of interest.

Planning your work – thumbnail sketch

The importance of planning before you start cannot be overemphasized. A series of thumbnail sketches – each taking no more than a few minutes, will not only help you become

familiar with your subject, focus your mind away from day to day distractions and 'get your eye in', it will let you explore the best format, composition and the position of lights and darks.

These sketches do not need to be polished, they are a working diagram to make sure you haven't overlooked something crucial. You should have enough detail to guide you, but not to constrain you. I usually do two or three thumbnails in different formats. Focal point and tones are my main concern. Sometimes numbering areas helps plan your working proc-

ess, so that you don't find yourself having to contort your arm to avoid a still wet area.

Once you are happy with your composition, take a moment to plan your colour palette – don't let it just happen! Do you want it to be warm or cool, high key or subdued? How can you use colour to establish the mood and feeling of the painting? Using fewer colours will often make for a stronger end result. Of course, your decision may revolve around a newly purchased colour you are desperate to use. If this is the case, think about what colours will set it off to its best advantage.

Consider how you will obtain the darkest tone. Rather than reaching for a ready mixed black or Payne's Grey, can you mix an interesting dark from elements within your palette? If it is a landscape, how will you mix your greens? To echo the sky colour in the green mix will help the painting hang together, for example. Even if you have an accent colour, consider where you might repeat it elsewhere in the painting – again, threes work well.

A selection of six or seven colours will not make for a boring painting, just as using every colour in your paint box will not make for an interesting one. The infinite variety you can obtain with a limited palette is one of the joys of painting.

What order do you want to work in?

It is a good idea to consider where you want to start and where you want to end. As you know watercolour is transparent, so generally we work:

- Light to dark
- Background to foreground.

However, due to the lifting properties of the paint on canvas you may need to adapt your working style. You will want to keep glazing to a minimum even if you use some of the additives introduced earlier. Get some darks in early on, as these define your tonal range, for example, the white of the canvas is your lightest, and the dark is your full stop.

You will also wish to avoid working over wet areas, as the paint will take longer to dry. Equally when working wet in wet, you may be able to paint a larger area than normal because it stays workable.

Look for obvious sections in your subject, so that dry edges form in natural places, not in the middle of a softly blended area.

A GOOD WORKING PROCESS

- Consider where your whites or lightest values will be and how you can save them. Do you need to mask or can you paint around?
- Block in shapes, while saving whites. Start at the background, or if you have no background block in, shape in your subject starting at the focal point.
- Get some dark in – you now have the lights and darks mapped out like the capital letter and the full stop in a sentence. Your greatest contrast is likely to be at the focal point.
- Add in the mid tones, the middle ground and the middle detail – this may be by selectively painting over areas of white space you do not want to keep, or gently glazing to adjust tone and hue.
- Add a few details – less is more.
- Stop – do not fiddle.

Step-by-step instructions – *Flying South*

The sight and sound of geese migrating is always a harbinger of the changing seasons. I wanted to capture the patterns of the wings of these elegant birds. Photographs are only ever inspiration and it is good to make them your own. I used several source pictures to work up compositions and settled on a square format to show off the lovely 'flick' of the bottom wing. Using the Rule of Thirds and thinking about the negative shapes, I played with the patterns made between the wings. I also considered carefully the order of work to ensure that I was not working over wet areas. As the focus is clearly on the geese, the background would only be the faintest tint. I selected a 90 x 90cm deep edge canvas and prepared it with three coats of ground. As I was working on a deep edge, I decided to continue the geese's bodies around the edge to enhance the three-dimensional nature of the image. Having worked all this out on a thumbnail, I only needed light pencil guidelines on the canvas to help with the placement. I decided to use a range of greens and blues that are very close on the colour wheel (analogous colours). No masking was required.

Step 1

As I am right-handed, I started with the top goose to make sure I wasn't working across wet areas. The markings of the geese give natural breaks, so I could ensure that the surface didn't get too wet or out of control. Starting with rich colour, I painted a simple circle with a highlight for the eye and using a damp brush, pulled the colour outwards. Glazing is difficult, so different colours were dropped into wet areas wet in wet, to create multiple colour washes. A little colour was allowed to go into the pale areas to form

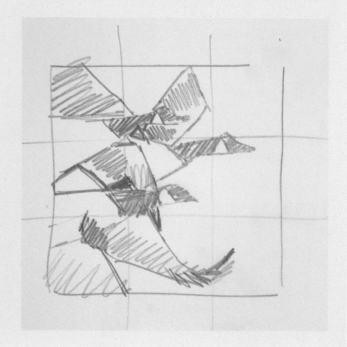

Using the Rule of Thirds, and indeed Fibonacci's sequence, along with leading lines, this thumbnail establishes a composition and order of work. My aim is for a muddle of wings that was quite ambiguous.

Step 1: Starting with the top goose, rich colour is used and pulled outwards from the eye. A sprinkling of table salt breaks up the pigment to add visual interest.

the shadow and a small amount of table salt created interesting feathery texture (see the next chapter for texturing techniques). Note how the small white areas around the beak are so important for indicating the form and also, how using a thirsty brush to lighten areas creates the illusion of volume.

Step 2

The heads and necks of the two remaining geese were painted in the same way, adding a little more detail to the body markings on the nearest bird to pull it slightly forward. Edges were softened only to a limited extent as I wanted the movement to be in the wings.

Step 3

By this time the first neck should be dry enough to work around, so it is time to paint

Step 2: The remaining geese are painted in the same way.

the wings. They could be quite confusing so it was important to make sure there was light against dark or vice versa. This is called counter change and it is a really strong tool in the watercolourist's arsenal. I wanted a lot of movement in the wings to contrast with the neck and head, so I used a spray bottle to carefully soften edges. As you are further diluting the paint, the original mix needs to be slightly stronger.

Step 4

With the three geese completed, a hint of colour was added to the background. Originally I added too much, so I removed most of it using a sponge. Once dry, I used a few considered drops to help lead the eye. Can you see there is a faint echo of the triangle formed by the heads in the three main drops? Though they may look random, a carefully placed mark makes a huge difference. Once fully dry, I applied three coats of spray matte varnish.

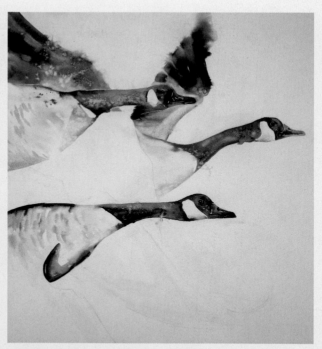

Step 3: Now the wings can be added, as the heads and necks are dry. Counter change (light against dark) is important to ensure the heads stand out clearly.

Step 4: Once the other wings have been completed, it's time to add a hint of colour to the background and a few splashes to help lead the eye.

TEXTURAL TECHNIQUES AND MARK MAKING

Sometimes a brush mark is just too predictable. Of course, watercolour brushes are things of beauty and no doubt you have your favourites, but there are many different ways of putting marks on a surface open to the inquisitive artist. By varying the marks, one can add interest and energy to a painting to intrigue the observer.

While watercolour is a physically flat medium, many techniques can be used to create the illusion of texture or to place the pigment. A spirit of adventure and experimentation lets you bring an added dimension to your work.

It may feel that you have gone back to infant school and that this is simply playing with the paint. But what is wrong with playing? By wondering what would happen if a certain object is used to apply paint, or whether something added to a wash would work magic, then you will be on the path to creating unique and exciting pieces.

However, a word of warning. Adding texture to watercolour can be addictive – the adage, less is more, is relevant. Too many textural methods in one piece will leave the eye nowhere to rest. Repetitive use of one single technique may become a cliché. So though you love a particular effect, always ask yourself 'what does this bring to the party?'. Don't let them become intrusive or detract from your painting. While you should never be afraid to try new ways of working, don't overdo them and ensure that they integrate seamlessly into your work.

The range of possibilities is only limited by your ingenuity. But before using the techniques in 'real' paintings, it is a good idea to make yourself a reference sheet.

You will find that different colours make a big

Look at the amazing textures you can create with wet in wet work and a sprinkle of salt. It can be addictive and you do need to guard against overdoing it.

LEFT: **I challenged myself to use as many brush marks as possible when painting this owl. If you look closely, how many can you see?**

Explore how textures work on the new surface even if you already use them in your paper-based work.

difference to the end effect. Even if you are used to working with different mark making and textural practices on paper, you will find that some work more dramatically on canvas, while others are disappointing. You will only find this out by trial and error, so it is worth creating test swatches on mountboard prepared with three layers of semi-absorbent ground.

As you prepare the reference sheet jot down ideas for applications, for example, the snow-flakes created by salt might be fantastic for creating the down on a bird's chest; water blooms might create the illusion of distant foliage.

Mark making

Water blooms

Water blooms or cauliflowers are loved and loathed in equal measure. Understanding why they form and learning to control where they appear, may help place you in the 'love' camp. When a mix containing more water is dropped into a damp (not wet) wash, the water naturally tries to move into the drier area. It pushes the pigment particles out of the way and forms the characteristic ragged edge of a bloom. To avoid them either leave a damp wash alone, or only add more concentrated paint into a wet area. The richer mix will not cause blooms to form. Conversely if you want them to appear, wait for

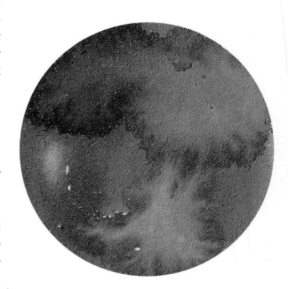

Water blooms.

sheen to start to go from the wash then drop in either clean water or dilute paint. You will find that blooms are dramatic on the canvas surface and can be used to your advantage if you embrace them.

Sponge

Natural sponges can be manipulated to give random paint marks which can be suggestive of foliage, multiple flower heads and so on. A sponge can also be useful for lifting out or softening edges.

Wet your sponge first and then squeeze out excess moisture otherwise it will suck up large quantities of paint. You will need to mix a fair amount of paint regardless as the sponge will absorb plenty. Controlling the amount of paint on the sponge is important if you wish to avoid blobs. It is also important to rotate the sponge slightly between dabbing, otherwise you will get a repetition of the pattern which will look far from natural. The effect can be built up wet on dry with multiple colours or to build up the density and tone of the mark.

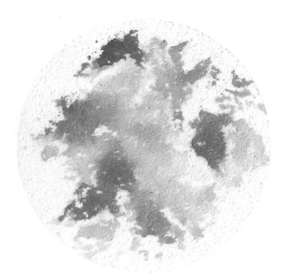

Sponging.

Printing

Many different items can be used to print watercolour onto your surface in the same way as sponging. Some of the most useful are the edges of card, credit cards and textured paper towels. The raised veins on the back of leaves can make interesting marks if painted and then pressed onto the surface.

Dry brush

Dry brush.

Using your watercolour brushes with limited quantities of thicker paint gives a totally different effect than the normal flowing washes. The brush loaded with a little paint (take the excess off on a towel) is dragged across the surface. It catches on the peaks of the surface, leaving the troughs untouched. You may find that on a canvas surface this texture is too regular for your taste, but on a rough semi-absorbent ground, dry brushing will emphasize the physical texture.

It is beloved of landscape artists creating the glint of light on water or implying texture in

foregrounds or dry grasses. However, it is also useful in building up subtle modelling and textures in animal's coats or human hair. You can use a fan brush but the mark tends to be too regular. The secret is to have exactly the right amount of paint on the brush, so it is worth practising.

Spattering

On dry or wet paper, spattering can be an excellent way to create the illusion of pebbles on a beach or leaves in a landscape. Random spatters can break up an overly hard outline.

Paint can be spattered in different ways. Some like to use an old toothbrush loaded with paint and then draw a thumbnail over it – this tends to create a fine directional spatter. For more circular drops a brush can be loaded with the wash and then tapped on a finger so that the drops fall in the right area. A paper towel is useful to mask off any area to be protected or should you wish for a crisp outline to the spattered area then a stencil can be cut.

Larger drops can be carefully placed to help lead the eye around the composition. A large brush jerked in a downward direction should produce decent sized drops or a pipette loaded with paint can give greater control of the placement.

If you accidentally spattered your work, you will find that one spot looks like a mistake, but adding a few more looks intentional.

Handle

People seem to forget that a brush has two ends. Using the handle, rather than the filaments, can create interesting marks. Either draw the handle through a damp or wet wash, or dip it into your paint and draw with it. The thin, broken lines tend to be energetic and gestural;

Handle.

totally different from the mark of a rigger for example. Sticks can also be used, particularly with ink in pen and wash work.

Stencil

Stippling or spraying paint through a stencil is an interesting way of incorporating strong

Stencil.

patterns in your work. You will need to ensure your paint is not too thin otherwise it will seep under the edges of your stencil.

Blowing

Blowing.

A short sharp puff of breath into a pool of liquid paint will create a random stream of thin lines. A straw allows you to direct the blown lines.

Spraying

A small water spritzer is very useful to soften off edges or to pre-wet your canvas, however, you can also fill it with diluted paint. Spraying through a stencil gives an interesting pattern, or you can mist a glaze over an area to avoid disturbing the previous washes.

Lifting out

One of the big advantages of working on canvas is the ease with which paint can be lifted. In a damp or wet wash, paper towels or a sponge will lift the paint back to the white of the surface. Once the paint has dried, a damp brush (a flat tends to have more spring) or a Magic Eraser should lift the paint. This means that masking fluid is less required than on paper. You can use a small stencil cut from a piece of watercolour paper if a specific shape is required, such as a white sail on a distant lake. Staining pigments will still stain the canvas, so you can use this property to your advantage, using an under layer of staining colour if you do not want it to lift or using the 'shadow' as an effect in itself. Remember that if you have used Aqua Fix or similar in your washes, or a workable fixative, you will not be able to lift once dry – that is the whole point!

Textural techniques

Often the results of texturing are better if you let the wash start to dry – the shine is just disappearing. Because watercolour dries more slowly on canvas, you may need to be patient. A hairdryer can speed the process, but sometimes all you can do is wait. If the wash is too dry, then the effect will be diminished too. Timing is everything.

Masking fluid

Masking fluid is a latex-based fluid that can be applied to the surface to preserve the white of the canvas, or indeed the colour of the under wash. While it can tear the surface of an absorbent paper, removing it from canvas is easy. But given that one of the main advantages of working on canvas is the ease with which paints lift, masking fluid is less used on canvas.

It should be noted that masking fluid can destroy a paintbrush. Either use an old brush to apply masking fluid or a rigid tool. Silicone

Masking fluid.

Sgraffito.

colour shapers are great and once the fluid is dry, it will just peel off the tip.

Cotton buds are very handy for an improvised tool. If you need a fine line, just cut the bud off the end. If you need a fluid brush mark, then dip your brush in a strong solution of washing up liquid before using the masking fluid. Dip it into the solution between each stroke and it will protect your brush fully. You can also spatter masking fluid to create random marks. These will be thick and tend to take a long time to dry.

Once the masking fluid has served its purpose, it can be removed by gently rubbing with a finger, leaving preserved areas. You may need to soften the edges of your retained marks to integrate them into your image.

You can also use masking tape without fear of tearing the surface. Ripping the tape rather than cutting gives a more interesting edge and should any paint seep under the edge, it should be straightforward to lift with a damp brush.

Scratching out

To give it its proper name, this is sgraffito. It is simply scratching through a layer of paint to expose what is underneath. On paper, it is done as a final touch when the paper is bone dry. It physically damages the surface and should a further wash be applied, it will sink into the damaged area and appear darker than the surrounding one. On canvas there is less danger of damage, though if using a sharp knife, care must be taken not to cut the canvas. Again, it should be used as a final touch or possibly as a last resort. It is often used to suggest highlights.

Salt

This, along with spattering, are the two texturing techniques most prone to over use. Paint a fairly intense wash and sprinkle a small amount of ordinary table salt into it as the sheen is starting to go. Wait for the magic, as snowflakes appear. When absolutely dry, scrape off the crystals with your nail. Rock salt will create larger marks and Epsom salts will create a different shaped mark.

If you use the salt too soon, you will simply end up with a salty puddle of paint. If the

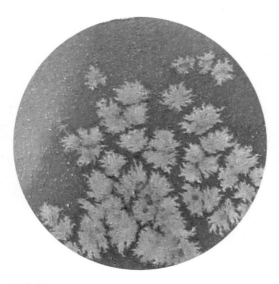

Salt.

paint is too dry, there will be no effect. Some pigments work more dramatically than others. Indian ink on canvas takes a salt texture in a fabulous way. Timing is everything.

Cling film

Cling film (Saran wrap) can be an excellent way of breaking up a wash, giving geometric stria-

tions of colour and tone. You will need to be very patient with this technique on canvas, but that patience will be rewarded.

The cling film is either crumpled or stretched out over the fresh wash (single or variegated). The wrinkles can be manipulated to give the desired effect. Long vertical folds might suggest bark, circular swirls might suggest petals. Move it around until you get a pattern you like. Leave it in place to dry, you may need to weight it down. On canvas this will take longer than usual as the plastic stops evaporation and there is minimal absorption. Don't use a hairdryer to speed things up for obvious reasons.

If you take the film off when damp, you will get a softer mark; if it is weighted and left to dry, you will get a crisp result. Similar effects can be obtained with foil and tissue paper (use acid free white paper as colour will bleed). You could leave the tissue paper in place to create a subtle collage effect, should you wish. (*See* Susan Miller's work in Chapter 7.)

Dishwasher rinse aid or alcohol

Placing a single drop of either dishwasher rinse

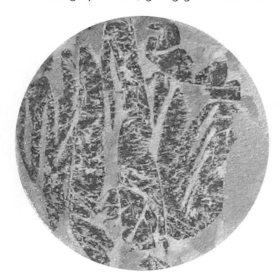

Cling film.

Dishwasher rinse aid.

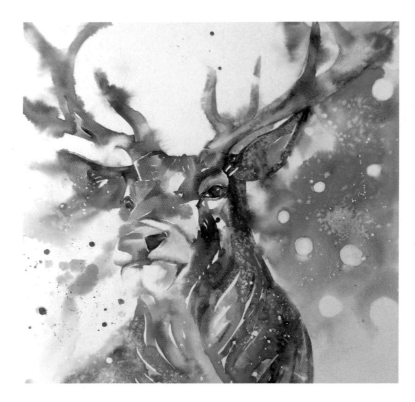

Sometimes a background needs a little lift. Dropping dishwasher rinse aid into the drying wash made interesting marks.

aid or clear alcohol into a drying wash creates a characteristic 'fish eye', with a dark centre and a paler circle around. Fabulous for nebula or underwater scenes and frankly, just fun to do! If the wash is too wet the effect will disappear as the water runs back into the area. If it is too dry the liquid will sit on top and do little. You can run a few drops through a wash to encourage more dramatic blooms.

Watercolour pencils/ colour sanding

While watercolour pencils are very convenient for working *en plein air*, they do not always give the intensity of colour that artists are look-ing for. However, a little imagination and they can be very useful in creating a subtle textural effect. Using a piece of sandpaper, the pencil is gently rubbed across the surface. The dust falls into the pre-dampened area and sticks. This

creates a fine speckle. Different colours can be built up layer on layer. The dust will only stick to a damp surface. If the surface is too wet, the colour will dissolve and form a wash.

Colour sanding.

This autumn woodland caught my eye. (Photo: Pixabay)

Wax resist

Wax and water do not mix. Using wax resist in your work is simply a more sophisticated version of doing magic writing, where one would use a candle to write a (often rude) word which was revealed when paint was brushed over. A heavy application on dry canvas will mean that any subsequent washes are repelled. You can either use a clear wax candle in which case the underlying colour will show through or coloured crayons or oil pastels can extend your mark making. The downside of this technique is that once the wax is on the canvas it cannot be removed and is difficult to see.

Textures in context
– *Autumn Light*

Light filtering through trees is a beautiful subject, but can be overwhelming. This autumn woodland caught my eye but I knew I would need to simplify it so that I could capture the essence of the scene. A few thumbnails helped to work out the composition. Thinking about the Rule of Thirds, I place the main light source at the upper focal point and a main trunk on one of the third lines. The horizon starts near a third line too. Simplifying the intersection of all the branches is necessary.

Wax resist.

Step-by-step instructions – *Autumn Light*

Step 1

A light sketch using a hard pencil indicates where the main shapes are. A 30 x 30cm deep edge canvas has been prepared with three layers of DIY semi-absorbent ground. Because it is a deep edge, I want to carry on the image around the edges. While not being fond of masking fluid it is very useful for this type of subject. I mask around the sunlight and then spatter the masking fluid randomly. Given that the trunk shapes are large, there really is no need to mask them.

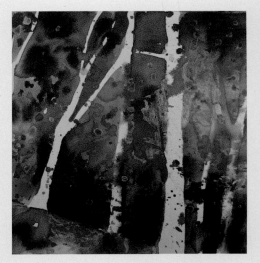

Step 2: A rich wash is applied wet in wet, avoiding the main trunk shapes.

Step 1: Masking fluid is applied to a light pencil sketch on a triple primed deep edge canvas.

Step 2

Selecting a range of rich warm colours, they are mixed to a creamy consistency and applied wet in wet radiating out from the sun, avoiding the main trunk shapes. As the wash starts to dry, clean water is dropped into it to encourage water blooms.

Step 3

Once the wash is thoroughly dry, which will take time, all masking fluid is removed. You can speed dry with a hair dryer. You wouldn't do that on paper as it might bond the masking fluid to the surface, but on canvas that is not an issue. You can now see what you have to work with.

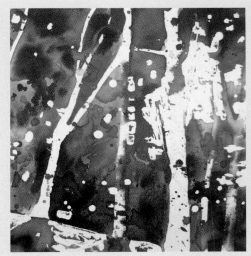

Step 3: Once masking fluid is removed you can really see what you have to work with.

Step 4

Using rich dark mixes, the main trunks are painted wet on wet. Smaller, more distant trunks are painted in slightly lighter tones to make sure they appear further away. By dropping warmer reds into the closer trunks, it will make them come forward, cooler colours appear to recede. Using a clean damp brush, the edges of the main light area are softened.

Step 5

Now it is time to consider the final touches. Using diluted white gouache, a little negative painting creates more light coming through the distant trees. A few spatters of the original wash are dropped around the painting to create foliage. Some of the white circles are filled in to soften the effect

too. The painting was finished with wax to deepen the colours and add a soft sheen to the image.

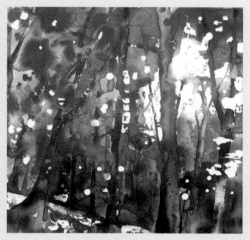

Step 4: Now the trunks are placed, a feeling of depth emerges.

Step 5: The final touches require careful consideration.

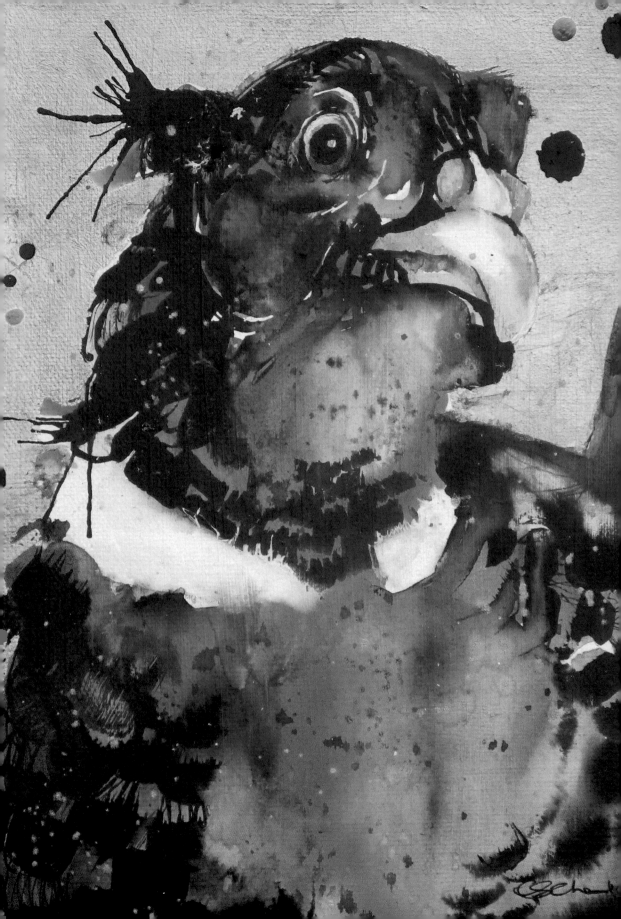

TAKING IT FURTHER

Now you have been bitten by the watercolour on canvas bug, you may wish to explore other techniques and develop further ideas. Collage and mixed media both benefit from the freedom of working on canvas.

Two plus two equals five

Line (or pen) and wash is a traditional technique which can be brought up to date when working on canvas. You can balance strong lines with loose watercolour washes, or delicate sketches with pastel washes.

Line and wash is at its best when the sum of the ink and the application of the watercolour add up to more than the individual parts. A coloured illustration is fine, but when the watercolour washes add drama and movement to the drawing, then it is so much more exciting. Outlining a painting might give it definition, but if the lines add direction and boldness, it will be more satisfying.

Whether you start with the ink drawing and

PEN AND WASH PRIMER

- The size of the line will be dictated by the size of the final piece. A smaller painting needs a finer line.
- Just as with pure watercolour, identify what attracted you in the first place; get to the heart of it.
- Aim for line and colour to do its job: $2 + 2 = 5$.
- Do not colour in your drawing or outline your painting.
- A wide range of tones is necessary in any painting. Don't assume the ink provides the darkest tones. If the line is fine, it won't.
- Loose, spontaneous lines work well – try to hold the pen (or brush) well up the barrel and not rest the hand too heavily on the surface. You may find completing the pen element with the canvas on an easel far more expressive.
- Broken lines are often more expressive than detailed precise ones.
- Don't worry if you place a line wrongly – just put in the right one as well.
- Try drawing without taking the pen from the paper.
- You do not have to only use lines. Consider your pen mark making just as you consider your brush work. You can hatch or stipple to add tonal value.
- The wash does not need to relate to the line work at all.
- You can go back over paint and add more ink or vice versa.
- Do not fiddle – stop too soon rather than too late.

LEFT: **Working on canvas opens up some intriguing possibilities. Here ink and watercolour is mixed with imitation gold leaf.**

add colour at the later stages, or start with the painting and add definition with ink towards the end, our aim is to make the sum worth more than the parts.

Materials

The most convenient way of applying ink is using a pen. You can get fibre tipped or roller ball pens with pigment ink. Do make sure they are waterproof and light fast. They are available in different widths and different colours. Traditionally people use black, but sepia can give a lovely result. The fibre tip pen may wear more quickly on the abrasive canvas surface.

Of course, you don't have to use fully waterproof ink. If you are using watercolour first, it does not matter if your ink is not waterproof, however, you may run into issues if you decide to add further washes. Some pens are not fully water-resistant and give a lovely soft effect as they run slightly when water is applied. You should check on lightfastness though, as alcohol-based inks are fugitive.

A dip pen with Indian ink might be a messier option, but gives a freedom and expression to your marks which is often lacking with a normal pen. Ink can be applied with a stick, feather or a stone, giving very lively results.

If you wish to move more into the realm of mixed media, consider Chinese ink, acrylic ink and ink sticks. Acrylic ink is interesting as you have the chance to use a white line, which can be very effective. Uniball Signo or Gelly Roll pens by Sakura, are my favourite opaque white pens.

Techniques

How you do your drawing is entirely a matter of preference – but it is worth having an experiment. Using one of your prepared off cuts of mount board, you can produce a crib

Different pens make different marks, but always be aware of whether the ink is lightfast and waterproof.

Pigment liners lack character in their mark, so you need to use them in inventive ways.

sheet of pen techniques to ensure the mark you select is perfect for what you want to communicate.

Why not try:

- Crosshatching
- Contour lines
- Parallel lines
- Stippling
- Criss cross
- Scribble.

Some people use very stylized lines or even inked patterns to great effect.

Think about contrast, and value – where is the light and dark? You don't need to just use line, you can use solid areas too and really create a strong image.

Brush and ink

Indian ink can also be applied directly with a brush and diluted, so that you produce a grey scale (grisaille) painting before applying colour. Indian ink works stunningly on canvas, and because it is waterproof, once dry it helps get around some of the issues caused by lifting. Having said that, should you need to remove dried ink, a very enthusiastic use of a Magic Eraser will shift most of the mark. It behaves and interacts in a totally different way to black watercolour, moving in water with a life of its own.

Because the ink reacts so well on canvas, you can consider blowing, splattering or dropping it onto the surface and using many of the texturing techniques you have already explored with pure watercolour.

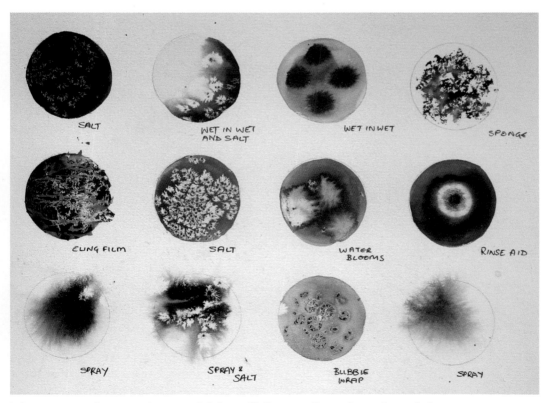

Ink on canvas takes texturing materials beautifully – try all your favourite techniques or invent new ones.

By using the ink as a grisaille (a tonal underpainting), I could enjoy adding coloured washes to create this image of a Green Man.

The completed *Green Man* was waxed to give a natural sheen and depth to the image, 70 x 70cm.

However experienced you are with pen and wash, it is worth making a reference sheet using a piece of prepared mountboard to explore how the ink reacts and to get a feel for the drying time and behaviour.

Consider all the texturing techniques you might use: soft edges, hard edges, dry brush, salt, cling film and so on. You may wish to use them in a judicious manner to avoid your painting becoming too 'busy'. Negative painting can work well with pen work to avoid the 'outlined' look.

Which comes first?

Traditionally most artists work with the ink first, but you can turn things on its head and indeed, alternate the ink and watercolour. You must ensure each layer is fully dry unless you want the ink to feather into the watercolour.

If you find it hard to be spontaneous with your washes, do them first knowing that you will be able to gain more control using line afterwards. And of course you can always add colour or more line once the previous has dried. It is far harder to do less, but more is always possible.

You can use ink to bring structure and definition to a painting that has lost its way. If you are struggling to get a contrast of tones and the painting has lost impact, then putting ink on top can save the day. Wait until the painting is entirely dry before applying ink, as the surface may be damaged and the ink may run. Of course, if you want the ink to be soft and diffused, then you will need to apply carefully to a damp canvas.

Bold graphic lines were important for this large study of a group of inquisitive calves. Working out the role of the ink and the balance against the watercolour before starting guided me the route to take.

Make a plan

We have already seen that a strong composition is the back bone of any work, regardless of the medium you are using. This is true of mixed media.

Actively choose the format of your canvas – portrait, landscape, square – each subconsciously adds a different feel to a painting. Consider where your focus of interest will be placed using the Golden Mean or Rule of Thirds. Think about shapes within your painting – such as diagonals, triangles and curves to lead the eye. What are you trying to say in the painting and what feeling are you trying to elicit? Reflect on the variety of tone – where will your

dark areas be and your lightest? What role do you want the ink and the watercolour to play in your painting? And what will be the balance of the two mediums or will one dominate?

It will be really helpful to do a five minute thumbnail sketch to work out some of these things – it will save you heartache down the road. But when your painting takes on a life of its own, you can still respond and change your path.

Collage and watercolour

The range of papers you can use in a collage is only limited by your imagination. Old newspa-

pers, magazines, failed paintings, tissue paper, scrap booking or Japanese papers would all work. Consider whether they are acid free or not. If you use newspaper, for example, you will find that it discolours with time. That doesn't need to be an issue, it is simply something to be aware of.

It is nice to include papers that are relevant to the subject matter – for example, farming or countryside columns as collage pieces for animal images or holiday brochures for the background of a landscape.

Collage pieces may play a couple of different roles. It provides a physical texture such as a torn edge or crumpled tissue paper. It may also provide pattern and colour. Whatever role you are using the collage for, do be careful that you don't go over the top. Too much pattern can end up being very busy and interfering with the delicacy of watercolour. You may find that

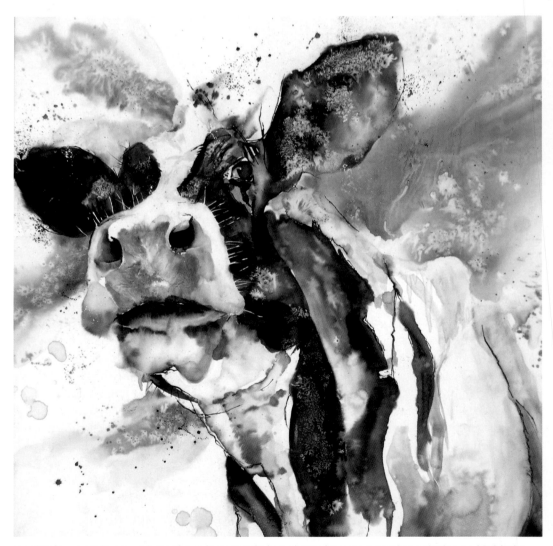

On this large scale cow, I kept the colour simple but wanted to use negative painting to highlight the animal.

it is time to switch to acrylic paints if this is the style you intend to pursue.

Shapes can be cut or torn, with torn edges having more subtlety and spontaneity. A cut edge can be more structural. The least successful approach is to cut out specific shapes as they tend to be rigid

Collage is most often used as a background, though it can be used at any stage of the painting. Papers can be arranged on the surface before sticking down to achieve a pleasing arrangement.

Either white, acid free PVA glue or a matte acrylic medium make a good glue. Gesso will adhere thinner papers. If you want the underlying paper to play a prominent role in the composition, you can then coat

This is a close up of a piece by Susan Miller, which you can see in the next chapter. It shows her use of tissue paper to add surface interest.

the entire surface with clear semi-absorbent ground. If this is your plan, you can stick the papers straight onto your canvas and finish with three coats of semi-absorbent ground. On the other hand, should you wish for the collage to play a more physical role or for the patterns to only peep through in places, consider coating with a white semi-absorbent ground. We have seen that one coat is not pigmented enough to cover the initial surface, so that you can use the ground to blend in edges and knock back patterns.

All that glitters is not gold

While collage is used to make an interesting surface, metal leaf can add a seductive shine to enhance your watercolour paintings. For centu-ries the glitter of real gold or other precious metals has been used – think of Renaissance frescoes or Gustav Klimt.

You can of course use metal leaf on paper, but it is a shame to have to then hide it under glass. Working on canvas, metal leaf adds a distinct 'wow' to your painting. Used alongside ink and watercolour is one of my favourite ways of working.

Gold leaf has a reputation of being difficult to work with and prohibitively expensive. If you turn your attention to imitation gold and are not intimidated by its fragile nature, then it is surprisingly easy to work with and you need no specialist tools to bring a bit of shine to your paintings.

Real gold leaf is metal hammered into extremely thin sheets which is sold between pieces of tissue. Its price fluctuates with the

Step-by-step instructions: *Otterly Lovely*

A small sketch will help you plan your painting.

Step 1: Having lightly sketched the composition, start on the head area using Indian ink and plenty of water to develop a full range of dark, mid and light tones.

Having studied lots of pictures of underwater otters, I created a thumbnail sketch of the final composition, trying to capture it in mid-twist. I wanted to place the otter centrally, but to also ensure there was a feeling of rotation. I made sure the circle formed by the otter was not closed and the main weight of its body is along the bottom third line. The bubbles rise along one of the vertical third lines. I used a 90 x 90cm deep edge canvas, so I decided to continue the water surface down the edges.

Step 1

Having lightly sketched onto the canvas, I start on the head area using Indian ink. The highlights on the eye are simply painted around, not masked. Leaving small white areas brings a sparkle to the painting. The ink follows the path of the water, so painting with a clean brush and then gently bridging to the ink area creates interesting flows and marks. You want to develop a full range of dark, mid and light tones.

Step 2

Moving onto the body and front paws, full strength ink is used to paint the animal, with a wet brush coaxing it to flow in the direction I want. Small areas are sprinkled with salt to break up the ink.

Step 2: Move onto the body area, using salt in places to break up the ink.

Step 3

The hind paws and tail are painted in the same way, using a spritzer bottle to soften edges and give the feeling of the tail whipping round. The water surface is painted concurrently to allow it to integrate with the otter. I want the feeling that the animal is at one with the water.

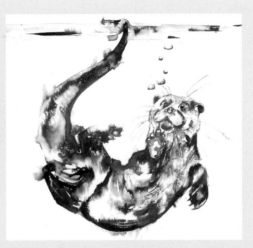

Step 4: Soften edges to add movement and consider final details.

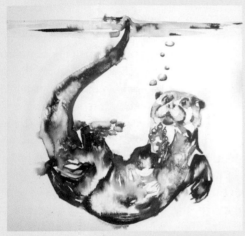

Step 3: Complete the tail and water surface, considering the curves and integrating shapes.

Step 4

The whiskers and bubbles are important features of the animal and composition, so they need to be placed carefully and not over cooked.

Step 5

Once the ink layer is fully dry, it is resistant. Limited colours are mixed into rich washes ready to be applied loosely wet in wet. It is important not just to colour in your ink painting, but to let the colour add movement and interest. These sweeping washes can be used without fear of disturbing the underlying ink. Though the background was largely left alone, I want to emphasize

the whiskers, so some negative painting is required and this needs to be balanced with washes in other areas. As I had used salt texturing in the animal, I also use it in the lower background wash. It is about balance, pattern and repetition. When fully dry, the painting is signed and sealed with three spray coats of matte varnish.

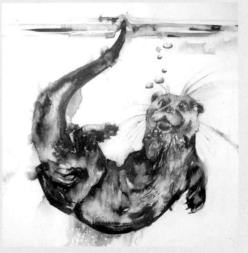

Step 5: Once the ink layer is dry, colour can be added in sweeping washes without fear of disturbing the painting.

world gold price. Imitation gold leaf is usually sold in larger 14 x 14cm squares. It is an alloy of copper and zinc, while imitation silver leaf is made from aluminium. Imitation leaf is easier to handle and a tenth of the price of its genuine cousin. Given that you may wish to break up the gold or paint over it in places, then it is quite sufficient. Leaf comes either loose or as transfer. The transfer leaf is fixed to a sheet of tissue which you take off once the leaf is stuck down. Loose is better if you need to apply over a textured surface, while transfer is easier to handle but less versatile.

Method

Watercolours will not adhere to a leafed surface, so first complete your painting. You will need a clean and draught-free environment in which to work. Any particles that become trapped under the leaf are visible. So if, for example, you have been using salt to add texture to your watercolour, make sure it has been removed both from the surface and from your work area. Leaf is more fragile than butterfly wings – the slightest draught will blow it away, so turn off fans and close windows.

The smoother your surface, the shinier the end result. So you may wish to lightly sand your ground between applications.

The colour of the surface under the metal will determine the overall end appearance as it acts as an undertone to the gold or silver leaf. Red beneath gold will give a warm rich finish, while black will give a cooler feel. So if you want an undertone, paint the area with concentrated watercolour, acrylic or ink. This stage is scary, as you are 'ruining' your painting. You can then deliberately put breaks in the leaf to let the undertone show through. Alternatively you could tint the gold size, which makes it easier to see where you have brushed it and also acts as a two-in-one underpainting.

Leaf needs to stick to the surface. The glue used is called leaf size and after it is applied it dries to tack – it is as sticky as a Post-it note, before the leaf is applied. You can get solvent or water-based size. The solvent will dry slowly, meaning brush marks will be less visible, but the water-based glue can be ready in just fifteen minutes. While any marks will be more obvious, it is pleasant to work with and imperfections add appeal to the finished result. The brush used to apply the size should be washed immediately after use.

Size should be applied as thinly as possible. Any brush marks will show through the final leaf, so make the marks in an appropriate direction to suit the composition. If you have a very intricate subject and want to apply the size with few brush strokes, you can protect the edges of the subject with masking fluid, before applying.

The water-based size reaches tack in fifteen to thirty minutes. The thicker you have applied the size, the longer it will take to dry. If you apply droplets, they are likely to take several hours to dry. If you are impatient and try to apply leaf before the glue has dried, your leaf will just end up as a soggy mess. You may see the 'open' time mentioned. This is the time it can be used for – often twenty-four hours or longer. So you can leave your piece overnight and still apply leaf the next day.

Rather than using a gilders tip, you can use the static property of a document wallet or wax paper to pick up the leaf as flat as possible without damaging the fragile sheet. If you don't mind ripping the sheets, simply pick them up with your fingers. Transfer leaf already has the backing paper, so this is not an issue.

Overlap sheets by a few millimetres. You can leave any gaps (these are called holidays), which can add to the design if you have a strong undertone, or you can use scraps to fill them.

After all the leaf is laid, use a bit of the spare tissue paper to protect the surface and gently rub over the leaf to ensure it is securely fixed.

Step-by-step instructions – *Golden Cat*

Step 1

This cat portrait on a 70 x 70cm deep edge canvas has been painted in the same way as the otter, working from a thumbnail to guide the composition and process and then painting with pure Indian ink and using water to draw the pigment out to develop mid and light tones. Once dry I had a lot of fun applying colourful washes, really making sure the eyes glowed, as they were the part that had attracted me in the first place. Whiskers and final details will go on after the gold leaf.

Step 1: The ink and watercolour painting of this cat were completed in the same way as the otter.

Step 2

The gold leaf naturally breaks as it is applied to the surface and having an under colour to glimpse through the gold sets a warmth or coolness to the piece. Seeing the white of the canvas appears as a mistake rather than design. I use a little acrylic ink to paint a few areas that I will leave untouched. This is a difficult part of the process, as you feel you are ruining your painting.

Step 3

Using a quick drying gold size, I tint it before application with watercolour. Not only can you see where you have applied the glue, it also acts as a 'bole' or undercoat.

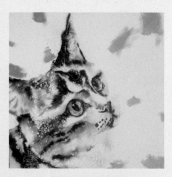

Step 2: Glimpses of colour peeping through the gold leaf is more appealing than seeing the white of the canvas.

Step 4

Once the size is dry to a tacky finish – about fifteen minutes

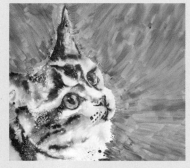

Step 3: Tinting the gold size helps you see where you have applied it and acts as an undercoat of colour.

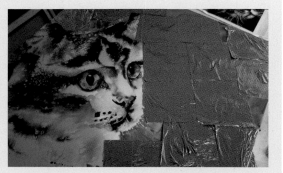

Step 4: Apply the gold leaf in sheets, mindful of the direction of edges as they will show in the final piece.

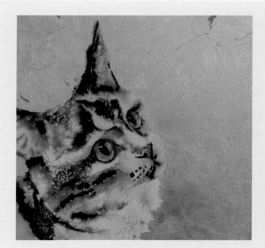

Step 5: Remove the excess with a soft brush.

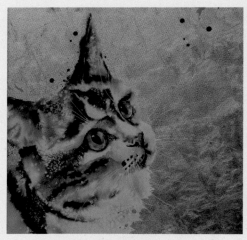

Step 6: Consider final details. Watercolour will not go on top of the leaf, but acrylic ink, Indian ink and gouache adhere.

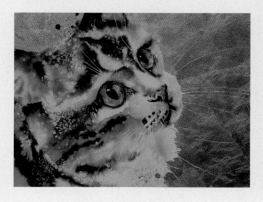

Step 7: A close up of the finishing touches which integrate the image and background.

– the imitation gold leaf is applied. As the joins show in the final piece, it is worth considering the direction of the sheets. If you don't want straight edges, then tear the leaf as the torn edge will be less obvious. I tried to echo the direction of the whiskers here.

Step 5

This is the moment of truth, as you remove the excess with a soft brush and reveal the final effect. If there are any gaps you don't want, you can apply a little size and use the skewings (the small pieces that have been removed) to fill them.

Step 6

Watercolour will not adhere to gold leaf, but acrylic ink, Indian ink and gouache will. So whiskers and final details are added after the leaf is in place. The leaf can create a very 'cut out' image, so careful use of a little ink at the end softens the outline and integrates the animal and background. This would be a lot easier in oil or acrylic, as they would both paint over the gold background.

Step 7

You can see here how the final touches bring the elements together. Once dry, a metal lacquer is sprayed on to stop the imitation leaf tarnishing. If you do not want the image to have a gloss image, you could mask the gold and use a matte varnish, then mask the image and use the lacquer on the gold.

Use a soft brush to remove the overlaps (called skewings). You would want to save and recycle real gold skewings; with imitation gold it is not worth it, though you can use them to patch any holidays. You could use a soft lint free cloth to gently remove the last bits. Avoid scratching the surface with, for example, a stiff brush at all costs.

Genuine gold does not oxidize, however, imitation leaf dulls over time, so it needs to be sealed using a metal lacquer or gloss varnish. A spray varnish is easiest and three thin coats is better than one thick one. Should you wish to do any work on top of the leaf – impossible with watercolour, but ink or acrylic will adhere to the surface, then this should be done before sealing.

Other surfaces besides canvas

The semi-absorbent ground we have been using can adhere to virtually any surface. A very smooth surface should be abraded with sandpaper before the ground is applied to help it to stick. You can even use it on glass – how about a hand-painted watercolour label on a bottle of wine for a very special present?

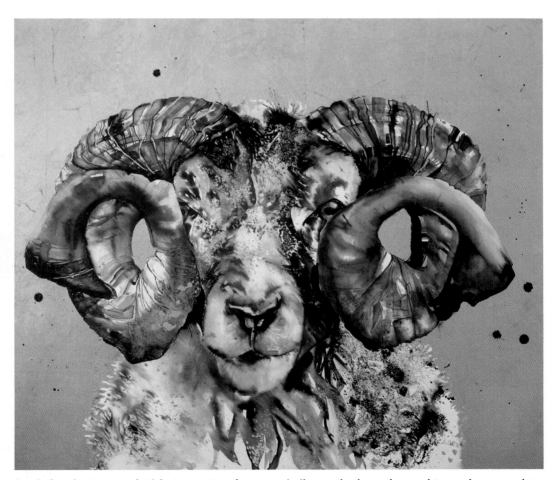

Semi-absorbent ground sticks to most surfaces, so similar methods can be used to work on wooden panels as in this ram.

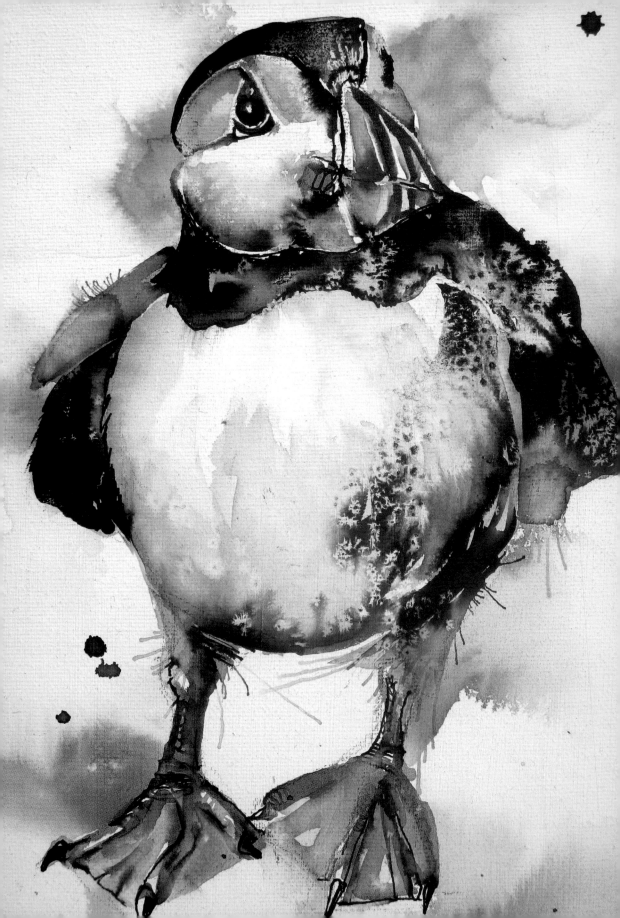

GALLERY, FINISHING AND PRESENTATION

Now that you are on the road to mastering painting on canvas, you will want to know how to protect your painting and present it to its best advantage. At the end of this chapter you can also see the work of artists working on canvas, showing a range of styles and subject matter.

You could, of course, have the canvas framed in the traditional way, placing it behind glass and using a mount to keep the image away from the glass. This rather defeats the object of being able to paint straight onto canvas.

Even if you have used a fixative between your layers you will still need to apply a final protective coat. The particles of pigment in watercolour are not coated in the more robust binder of linseed oil or acrylic polymer and are therefore more vulnerable to atmospheric pollution and UV light than oils and acrylics. While varnish can protect the piece from dust, UV and pollution, it does not form a physical barrier in the same way that a frame and glass can. Therefore a piece on canvas will potentially be more vulnerable than a framed work, however, the benefits of appearance, weight, and cost do outweigh any concern about potential damage.

Before you do anything

The sealing and varnishing of watercolour paintings is a non-reversible addition to the artwork that permanently changes both the nature and appearance of the piece. It is critical to understand what you are doing and to test the products you choose before applying any varnish to a watercolour painting.

Because the ground is absorbent, any varnish applied to the surface soaks into it and becomes a non-removable addition to the piece. Once varnished, the watercolour can never be returned to its original condition.

Some purists would say that varnishing a watercolour turns it into a mixed media piece,

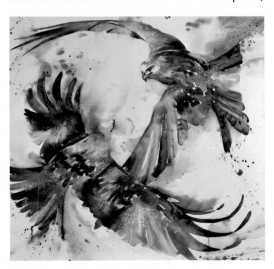

Red Kites, 100 x 100cm. Before protecting and finishing a painting, realize that this is an irreversible step.

LEFT: **Simplicity is the key here in this small study of a puffin. Ink and watercolour on a 25 x 25cm deep edge canvas, cropped.**

There are plenty of options when finishing your painting, depending on the final result you are after.

but those same purists wouldn't be happy that you are painting on canvas, so feel free to ignore them.

You should be aware that the appearance, texture and feel of the painting may change. In general a gloss varnish will darken colours, while a satin or matte varnish may lighten colours. When varnishing watercolour paintings, be aware that although an increased number of coats will result in greater protection against UV radiation, it also reduces the textural quality of the surface and paint.

If you intend to use a high gloss finish you may wish to photograph your painting before applying it to avoid glare.

Varnish

A varnish functions as a tough yet flexible protective film over artwork. It is designed to reduce damage caused by humidity, dust, dirt, smoke, ultraviolet radiation, scuffs and scratches. Varnish is there to protect against anything that will compromise the longevity of artwork. When applied on weakly bound media like watercolour paint films, varnish also has the

WHAT TO LOOK FOR IN A VARNISH

Is it archival?
You want your artwork to stand the test of time. You have selected acid free ground and lightfast pigments, so it makes sense to select a varnish that will not degenerate, in particular yellow, over the years.

Is it formulated with UVLS (Ultra Violet Light Stabilizers)?
A UV resistant varnish works to reduce the effects of UV radiation. They create tough but flexible films that are suitable for interior applications.

How is it applied?
Varnish can be applied via an aerosol or brushed on. Aerosol layers tend to be thinner and therefore more are required to get the same level of protection. Brushable varnish tends to be more economical and would only require a few coats, but using a brush on the fragile watercolour may cause streaking.

What is the final finish?
Varnishes come in gloss, satin or matte. Matte will be closest to the finish on traditional paper, however, gloss will retain clarity. The matting solids in satin or matte can give a dusty look to the piece.

Is it water or solvent based?
Using water-based materials over water sensitive media could potentially lead to bleeding or streaking, especially when brush applied. Solvents need good ventilation and can be unpleasant to use. You may also be concerned about the environmental and health impacts of these solvents.

ability to seal and hold the pigment and binder in place.

The quickest and easiest application is to spray directly with an archival varnish. Using an aerosol allows the varnish to be applied without touching the fragile watercolour.

Begin with gloss in order to retain clarity and finish the last coat or two with the sheen of your choice; gloss, satin or matte. Three coats should be sufficient, but certainly no more than six. Though this might enhance the UV protection it will impact on the texture of the piece.

If you were to apply all the coats in satin or matte, the result could be a cloudy or dusty look due to a concentration of matting solids.

Ghiant H2O

Available in gloss or matte, these low solvent sprays offer an interesting alternative. Because they are in aerosols they are easy to apply and I have found they don't cause marking or streaking.

These water-based varnishes give the same results as traditional aerosol-spray varnishes. With 90 per cent less solvents than a normal spray plus thirty-five per cent fewer VOCs, they're also UV resistant and will not yellow. For painting protection, spray three thin layers at intervals of at least twelve hours. Ensure that the paint is dust-dry and dry to the touch before application.

Isolation coat

An initial application of a non-removable isolation coat seals absorbent areas and allows a more even varnish application, while also protecting the artwork if the varnish is ever removed. To avoid bleeding or streaking of the watercolours, always spray apply the isolation coat rather than use a brush.

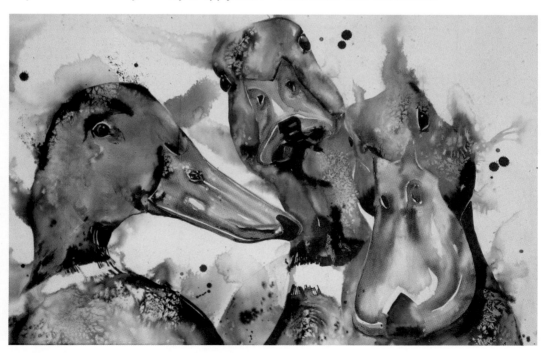

Painted on a lovely bespoke canvas, these ducks (cropped from 170 x 50cm) were finished with several coats of matte varnish.

Once an isolation coat or two is applied and allowed to fully dry then any suitable varnishes may be used or a wax finish.

Wax medium

Waxing your watercolour offers an entirely new finish. It can be buffed to a gentle sheen or left matte and brings a lovely depth of colour to the finished piece.

Wax medium may be used as a top coat on a watercolour painting with or without an isolation spray coat. Consider the wax a non-removable coating if it is applied without first sealing the painting.

Applying a wax medium on watercolour has many advantages: it will protect the surface from humidity and is easy and fast to apply. It also has a nice smell that is less offensive than varnish.

Dorland's Wax, Gamblin Cold Wax Medium and C Roberson Beeswax Picture Varnish are all options, though the latter has a strong mineral odour. They are a simple mixture of pure beeswax, mineral spirits and a small amount of alkyd resin. They can be used directly from the container and dry to a completely transparent finish, improving the luminosity and clarity of colour.

Once dry, the surface is water resistant and can be cleaned with a dry or even damp cloth. You can also wax watercolours on paper if you wish to.

Applying wax medium

The wax bonds with the watercolour down into the semi-absorbent ground. Because it's a petroleum product, it does not reactivate the watercolour. You do not need to seal your watercolours before waxing. Though you should apply an isolation coat if you think you may ever have need to remove the wax finish.

Rub the wax medium on gently and thinly with a soft, lint-free cloth. Apply it in a circular motion. On heavily textured ground, it may also be applied by gently stippling it on with a soft natural bristle brush. Use just enough wax to go on smoothly without rubbing the paint. As soon as your cloth 'drags', scoop out more wax. Continue applying the wax over the surface and around the edges of your painting. Pay particular attention to the corners. Dorland's can be applied with fingers and it is a wonderfully tactile experience.

If you put the wax on thickly the surface will retain the brush marks or swirls that you leave, even after buffing. Generally multiple thin coats work better than one thick coat.

Waxing a watercolour is a rather nice tactile process. The secret is to let it fully dry over several days before buffing.

Allowing the wax to dry for a day will result in a matte finish. For a satin sheen, allow the wax to dry for four to six hours or overnight (depending on the wax and how much you have applied), then carefully buff the surface with a soft cloth. Buff gently to avoid scratching the surface of the watercolour painting. On more heavily textured surfaces, a clean shoe polish brush may be more effective at reaching deeper textures than a cloth.

You may wish to repeat the application to get a greater depth of sheen. Once it's dry and buffed, examine the sheen. It seems unlikely that a third coat will be needed, but you can at this stage if you feel it's necessary.

Acrylic medium

If you like the feeling of watercolour coupled with the look of an oil painting you could coat your finished painting with an acrylic medium.

A gel medium is a transparent paste which increases transparency and brilliancy and gives the paint a textured quality. It dries quickly, leaving a water resistant film.

A gloss or semi-gloss medium is a milky white liquid that increases the gloss and transparency of watercolours.

Either can be applied with a soft brush to leave the brush marks showing. Seal first a coat of gloss varnish to avoid disturbing the paint underneath.

Backing

Once a painting is on the wall, it should be safe from damage. However, canvases are vulnerable to being punctured when moved or stored. You can protect your paintings by backing the canvas. This has two additional advantages. Firstly it gives a more professional finish and enhances perceived value – after all, if you do not care about your paintings and their presentation, why should anyone else? Secondly, on larger pieces it can potentially help prevent warping.

There are a couple of options for backing. Thin hardboard can be cut to 2cm narrower than the finished piece and then screwed in place. Screwing rather than nailing allows the backing to be removed should the canvas need tightening. Once in place, use framers self-adhesive brown tape to cover the edges of the board. You can use gum tape, which needs to be wetted, but you may find it struggles to adhere to the canvas.

The downside of using hardboard is that on larger work it adds considerable weight and needs to be sawn to size. An alternative is to use the black plastic surface protection sheets which are widely used to protect floors and walls during renovation work. Correx and Proplex are two common brand names and it is available from DIY shops at a very low cost. It can be cut to size with scissors and fixed in place using a staple gun or screws. It is far lighter in weight and offers no structural support, but

A protective backing is not absolutely necessary, but if you are taking paintings to shows and exhibitions they will save damage.

it will protect the back of the painting against knocks and puncture. The edges should be finished with tape as before.

D rings and stringing

D rings, either single or double depending on the weight of the picture, can be screwed into the stretcher bar about a third of the way down the two side edges. Take care to always select fixing hardware which is more than strong enough.

Picture cord or wire is then tied tightly across the back of the frame. Do not use cotton cord as it will rot over time. Laboratory tests show that polyester has better stretch characteristics than nylon. Polyester does not rot, nor will moisture from the atmosphere change its characteristics. You are looking for longevity so you do not want to be constantly tightening the cord.

To allow for 'shock' loading, the picture weight should be no more than about one quarter of the breaking strain of the cord. The breaking strains are regularly tested for reputable brands. If a picture falls off the wall it is unlikely the cord has broken but that it has become untied from the eye, or the eye itself pulls out, breaks or comes open.

You can use a single cord and tie it to each D ring in a series of over hand knots. Alternatively you can use a double cord, which is easier to get tension on and thread through both D rings before tying off. Every framer seems to have a favourite knot, which they swear will never slip. You can do your own research or simply use a granny knot. You can use a match to melt the end of your cord to ensure it will not fray or use a piece of tape to finish off the ends.

If you live in an area of high humidity or a house with damp walls, consider placing self-adhesive bumpers on each of the lower corner. This keeps the picture clear of the wall and allows air to circulate. Damp cannot bridge the gap and be absorbed into the painting.

The aesthetics are up to you, but do take pride in the presentation of your work so that something as simple as the hanging does not distract from the quality of your painting.

Framing

Framing is such a personal choice. It is fair to say that a well-chosen frame can make a mediocre painting shine and a poorly chosen one can detract from the most beautiful piece. It is very galling when people comment on the frame and not the painting. They can be easily damaged in storage or transit, especially at the corners, so consider carefully before going to the expense of framing. If you have painted on a deep edge canvas it is not required.

Tray frames, where the painting sits in the rebate and there is a space between the frame and the canvas, are contemporary and currently popular. They tend to be available in limited colours and finishes. A traditional frame covers a small amount of the edge of the canvas, while the edges can still be seen in a tray frame.

A good framer will be able to advise you on all aspects of the job, but if you are considering doing it yourself, here are a few considerations.

First of all, the picture should not be a snug fit in the frame. You need about a 2mm gap between the picture and frame all round to allow for all the components to expand and contract, or you may well find your frame coming to pieces.

There are special clips for holding the picture in the frame. Some are offset clips, or spring clips that screw to the back of the frame and go over the back of the picture. Others are clips that sit inside the frame between the picture and frame.

Vintage frames can be found in junk shops and though they may require repair, they can

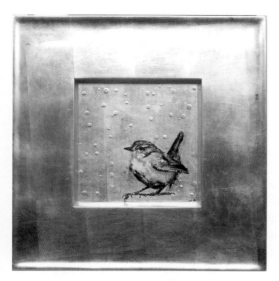

Frames can sometimes be found in junk or vintage shops. It can be fun to work backwards, for the frame to inspire the painting. This little wren was prompted by the oversized frame which used to have a mirror in it.

tap into the passion for all things retro, or into the upcycling movement. You may not be able to find a canvas to fit the frame exactly, in which case using a rigid panel might be an easier bet, prepared with semi-absorbent ground.

You can use D rings screwed to the back of the frame with cord between them as before. They need to be placed about a third down from the top of the frame. It is also a good idea to put small felt bumper pads on the bottom corners where the picture touches the wall.

Care and display

Think about where you are going to display your work. Despite selecting light fast pigments and protecting with a UV finish, it is advisable not to display your work in direct sunlight. This holds true of all original artwork, but is more pertinent to watercolours. Certainly avoid conservatories and similar high UV locations.

Because canvas is made from natural materi-

als which will expand and contract with fluctuation in the atmosphere, it is best to avoid areas with wide temperature variations or high humidity. Try to avoid hanging paintings above radiators or heating vents and in bathrooms. Avoiding radiators is often impossible, but at least be aware of the danger.

Though a properly protected canvas can be wiped with a lint free cloth, it makes sense to not hang it where it is likely to be splashed. Be careful in kitchen and eating areas.

Periodically check the cord and hanging hardware to ensure nothing has become loose or frayed and simply dust with a soft cloth. If there is any evidence of damp or condensation, do put spaces at the back of the bottom corners to keep it clear of the wall.

Gallery

To illustrate many of the techniques discussed in this book and as inspiration on your watercolour journey, it is lovely to be able to share with you the work of practising artists from the UK, US and Australia.

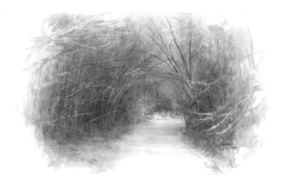

***Nature's Cathedral*, 61 x 92cm, painted on Yes! stretched canvas, by Charlotte Laxen. She uses a very light touch when layering with a soft hake brush, but no fixative additives. She may need to go over areas to bring back definition and here, she used a touch of white gouache to bring out the closest snowy branches.**

Heavenly Hollyhocks, 20 x 23cm on Yes! canvas panel by Charlotte Laxen. She uses QoR watercolours because of their vivid colour and aims to paint only the necessary, leaving out the rest. She finishes her paintings with 5-6 coats of UV archival matte varnish.

Mare Simmons loves exploring how her favourite watercolours behave on canvas. She finds a big contrast in drying time, which allows her to manipulate the paint and create effects that are not possible on paper. She paints in layers and enjoys the vividness of the colour on her preferred smooth canvas. *Mountain Honey* (40 x 50cm approximately) is an abstract botanical that captures the spirit of her city in the beehive state; Salt Lake City. Liquid gold leaf was used to highlight the honeycomb design.

Waterpocket Blossoms (20 x 25cm approximately) relies on overlays. Mare Simmons uses a light touch and takes into account the extended drying time to prevent the background designs from being drowned in water and pigment. The floral pattern dried for several days before painting the open pockets to let the backdrop peep through, and washed the paint carefully across the remainder of the canvas to create a subtle fade effect.

This study of a gum tree by Australian artist Cheryl Bruce (25.5 x 25.5cm) reflects her love of the environment in the Central Coast area of New South Wales. She says she is drawn to the shadow rather than the light, loving to depict the changing colours in the shadow passages of her subject.

In this larger than life flower (*Fanning the Flame*, 50 x 50cm) by Jill Griffin, each petal is painted individually, wet into wet to avoid lifting of layers and exposing the primed canvas beneath. Speed is important and careful observation of how the paint behaves as it dries is essential to time intervention of additional tone, blending and softening where required.

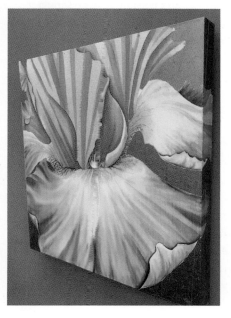

Detail of Jill Griffin's iris painting. These are bold statement pieces created on deep edge box canvases so that the flower can be 'wrapped' around the canvas by painting the sides as a continuation of the front composition.

Flaunt, 30 x 30cm, by Jill Griffin. This pansy has been gilded in 23kt gold leaf. The edges are finished with gold gouache.

Baboon, 13 x 18cm, watercolour and embroidery on canvas. Karen Grenfell combines loose watercolour, clever wordplay and exuberant embroidery. Once the painting is completed it is varnished with light spray of acrylic matte varnish, then removed from the stretchers. 'Silks' (usually cotton mix – not real silks which would be shredded going through the canvas) and machine embroidery cottons are used, with beads added last. The canvas is then restretched.

Pigeons, 13 x 18cm, watercolour and embroidery on canvas, was inspired by Karen Grenfell's childhood trips to London. Her father made up the words on the picture (Hello Big Ben, and so on) to sing along with the chimes. After painting and sealing, the canvas is removed from the bars to allow easier embroidery. Karen also uses this technique on paper.

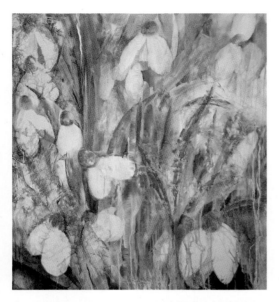

Tread Softly, 100 x 100cm. Susan Miller likes to disturb the surface to create unpredictability. She uses tissue paper, but also fibres or torn watercolour paper. She works very wet in many layers, in response to the outcome of the previous layer. Once the work on canvas is sufficiently developed, she puts the work on the wall to allow the work to drip naturally.

Details from *Tread Softly* by Susan Miller.

Alleluia, 100 x 100cm, was an emotional response after Susan Miller attended composer Sir John Tavener's memorial service at Westminster Abbey. The pose and otherworldliness are how she remembers him. She used a small amount of acrylic to get the very rich red in the shadow, but normally limits herself to watercolour.

GLOSSARY

Every area of interest has its own language, which can make it somewhat confusing to the outsider. Watercolour is no exception and you might even consider it a deliberate way of having a bit of mystique. This glossary aims to shed light on the commonly used terms you will find in the watercolour world.

Accent A small area of colour placed in a painting for emphasis. It may be a detail or brushstroke.

Aerial perspective (also called atmospheric perspective) Creating the illusion of distance by reducing detail, cooling colours, reducing saturation and contrast.

Analogous colours Colours that sit next to each other on the colour wheel, such as red, orange and yellow.

Artist quality Watercolour is available in artist or student quality. Artist quality should use the finest pigments in terms of lightfastness and intensity, with no fillers.

Centre of interest Also the focal point.

Charging Two or more colours are mixed directly on the surface. Usually a slightly stronger mix of one colour is touched into a still wet area of another.

Cold pressed paper This is also called 'Not'. It is the mid texture of traditional watercolour paper and the most versatile. You will see some grounds equate their final texture to hot pressed, cold pressed or rough.

Complementary colour These are pairs of colours found directly across from each other on the colour wheel, for example, red and green, yellow and purple. When mixed they will neutralize or grey each other. Used alongside, they intensify the appearance of the other colour, a property exploited by the impressionists.

Composition The structure of the painting or drawing that forms a pleasing image. The Golden Mean is an important law of composition.

Drybrush A brush loaded with a small amount of concentrated colour is brushed on the dry surface. Higher parts of the surface will pick up the paint, while troughs will remain untouched. It is used to make areas of broken colour.

Flat wash An even layer of colour created by strokes of paint being placed next to each other, which should dry without streaks.

Frisket *See* masking fluid.

Gesso A commonly white liquid used to prepare the surface for painting. It is made from a binder, chalk and pigment. Acrylic gesso is different from one designed for oil painting.

Glazing Applying a thin, transparent wash to alter the appearance of the original colour.

Golden Mean (also called the Golden Ratio and equates to the Rule of Thirds) A theory useful in composition. Fibonacci, an Italian mathematician in the Middle Ages, used

it to explain why we find certain relationships visually pleasing. In mathematics, two quantities are in the Golden Ratio if their ratio is the same as the ratio of their sum to the larger of the two quantities. It is 1.61, but can be simplified that if a picture is divided into thirds, the focus of interest should lie on one of the intersections.

Gradated wash (variegated wash/graded wash) A wash which gradually changes from dark to light or vice versa, or from one colour to another.

Grain The basic texture of the surface, usually fine, medium or rough also hot pressed, cold pressed/Not and rough.

Ground A substance used in the preparation of a canvas before painting.

Highlight A point of intense brightness, such as the reflection in an eye. The lightest area of a painting – usually white.

Granulation A property of certain pigments causing them to settle into the lower areas of the surface and giving a mottled effect.

Gouache (also known as body colour) An opaque form of watercolour. White is very useful for small highlights.

Gum Arabic The binder used in watercolour to hold the pigment together.

Hard edge A sharply defined edge to an area of paint.

Hot pressed A smooth surface, produced by putting paper through hot rollers when manufactured – like ironing a cotton shirt.

Hue The name of the colour, rather than its

lightness or darkness (tone). If used in a paint name it denotes the colour is the equivalent – often used in student quality paints, as they would be cheaper ingredients.

Intensity The saturation, brightness or strength of a colour.

Layering *See* glazing. Applying one colour over another to change its hue, value or intensity.

Lifting out Removing paint from a surface to correct mistakes or change value. Lifting out from canvas is easier than on paper.

Lost and found edges Indistinct or broken edges to an area of colour, which can help suggest movement and add interest. The eye tends to infer an edge is there from other information in the painting.

Masking fluid A latex fluid used to preserve areas (usually white). It may damage brushes and can rip a paper surface, though not a canvas one. Sometimes called frisket.

Modelling paste A key ingredient to making DIY semi-absorbent ground. It is a lightweight paste used in acrylic painting to build texture. It should not shrink or crack, but beware not all pastes dry white.

Monochrome A single colour, using its range of tone.

Negative space The area around an object. Negative painting is very useful in watercolour to suggest an object by painting the area around it.

Not The name of the mid-textured surface used in watercolour. So called because the paper is not put through hot rollers.

Opaque colours This is the opposite of transparent. All watercolour is transparent; however, some pigments let the light pass through them more readily than others. Useful property to understand when glazing or doing pen and wash work.

Palette knife (also known as a painting knife) A small spatula-type knife used to apply, shape or remove paint.

Pan paint Watercolour comes in tubes or small cakes called half-pans or full-pans. More portable than tube colours.

Pigment The powder mixed with gum Arabic to create watercolour. They may be organic or inorganic, naturally occurring or artificial.

Primer A primer is a preparatory coating put on materials before painting. Priming ensures better adhesion of paint to the surface, increases paint durability, and provides additional protection for the material being painted.

Rough The most heavily textured surface, compared to hot and cold-pressed/Not.

Semi-absorbent ground The preparation used to stop the canvas surface repelling watercolour, making it behave more like a paper surface.

Soft edge A gradual or fading edge to an area of colour.

Staining colours Colours which sink into the surface, making them difficult to lift. Rarely an issue on canvas.

Temperature Depending on where the colour appears on the colour wheel, it will be described as warm or cool. Cool colours veer to blue, while warm colours veer to red. Cool colours recede; warm colours advance.

Thirsty brush A clean damp brush used to suck up excess moisture or paint.

Thumbnail sketch A useful small sketch to explore the design and tone of a painting and to plan the approach.

Tint By adding water to the colour its intensity is weakened.

Tone (*see* value) The lightness or darkness of a paint. Generally, more paint darkens the tone and more water lightens it.

Transparent As opposed to opaque, colours that allow light to pass through.

Value (*see* tone) The lightness or darkness of colour.

Variegated wash When an area of colour merges seamlessly into a different hue. Similar to a gradated wash.

Wash A thin layer of watercolour – it may be one constant colour (flat), change from dark to light (gradated) or from one colour to another (variegated).

Wet on dry A wash that's applied to a dry surface.

Wet in wet Allowing colours to mix by painting on an already wet or damp surface.

Wet up to wet Allowing two areas of wet paint to merge at the edges.

SUPPLIERS

UK

Art Discount
An excellent range of pre-stretched canvas, canvas rolls and accessories. Part of Granthams graphic supplies.
www.artdiscount.co.uk

Cass Art
Wide range of art materials, via a network of shops and online.
www.cassart.co.uk

Cornelissen
Specializing in hard-to-find artist's equipment such as pigment, gouache and gilding materials.
www.cornelissen.com

Graff City
Suppliers of spray paints, fixatives and varnishes aimed at the graffiti artist.
www.graff-city.com

Great Art
Gerstaecker UK Limited, trading as GreatArt, is one of the UK's leading catalogue and web shop for quality art materials.
www.greatart.co.uk

Jackson's Art Supplies
Jackson's is a well-established maker and supplier of art materials. The sales staff can offer you advice and guidance so you buy exactly the right product.
www.jacksonsart.com

Ken Bromley Art Supplies
Supplies and manufactures art materials at discount prices, with excellent delivery.
www.artsupplies.co.uk

Lawrence Art Supplies
High quality art supplies from painting materials to printmaking equipment.
www.lawrence.co.uk

SAA
The SAA is a worldwide community of artists offering inspiration, information and advice. It also has an excellent mail order of discount supplies.
www.saa.co.uk

Pegasus
Beautiful bespoke canvases as well as online supplies and a retail outlet in Stroud.
www.pegasus.co.uk

USA

Blick Art Materials
Blick Art Materials is a family-owned retail and catalogue business that supplies professional and amateur artists.
www.dickblick.com

Cheap Joe's
Art Supplies, craft supplies and artist resources.
www.cheapjoes.com

Daniel Smith Art Supplies
Daniel Smith is an art supply manufacturer and retailer. Dan Smith, a noted printmaking artist, founded the operation in 1976.
www.danielsmith.com

Golden Artists Colors Inc.
Golden focuses on paints used in fine art, decoration, and crafts. It is an employee owned company which produces QoR watercolours.
www.goldenpaints.com

Jerry's Artarama
Jerry's Artarama is a discount art supplies and materials company. It has an extensive custom canvas department.
www.jerrysartarama.com

Michaels Stores
Michaels is the largest American arts and crafts retail chain.
www.michaels.com

Germany
Schmincke Künstlerfarben
A manufacturer of high quality artists' watercolours and mediums.
www.schmincke.de

Australia
Art Materials
Offering online art supplies, graphics materials at discount prices, Australia wide.
www.artmaterials.com.au

Art Scene
Online and retailer of art materials and frames.
www.artscene.com.au

Art Shed
Family-owned art supplies business that has been in operation for over thirteen years.
www.artshedonline.com.au

South Africa
Artattack
Online art shop specializing in all art and graphic supplies including canvases and watercolours.
www.artattack.co.za

Affordable Art Supplies
Online discount art supplies.
www.artsavingsclub.co.za

Addicted to Art
Online art supplies.
www.addictedtoart.co.za

Canada
Curry's
Quality art supplies, online and via eleven stores.
www.currys.com

Deserres
Via stores and online, quality art supplies.
www.deserres.ca

Opus Art Supplies
Opus is an independently-owned local business, supplying the visual arts community with art materials and education, via seven stores and online.
www.opusartsupplies.com

USEFUL RESOURCES AND FURTHER READING

Useful resources

Royalty free photo websites
Pixabay
www.pixabay.com
Over 1.5 million royalty free stock photos and videos shared by the generous community.

Paint my photo
www.pmp-art.com
Established in 2010 by Roy Simmons to help artists around the world who were struggling to find copyright-free photos to use for inspiration.

Further reading

https://michaelevermette.com/page/2843/preparing-a-canvas-for-watercolor-painting

Acrylic Illuminations – reflective and luminous acrylic painting techniques. Nancy Reyner, North Light Books.
Though aimed clearly at acrylic painters, her techniques on gilding can be applied to the watercolour canvas.

Watercolor Tricks and Techniques. Cathy Johnson. North Light Books
If you are looking for new (and old) mark making and texturing techniques, this is a useful book.

FEATURED ARTISTS

Cheryl Bruce
www.cherylbrucecreativ.com

Karen Grenfell
www.mimiloveforever.com

Jill Griffin
www.artfinder.com/jill-griffin

Charlotte Laxen
www.charlottelaxen.com

Susan Miller
www.susanmiller.org.uk

Mare Simmons
www.maresimmons.com

INDEX